Coptic Monasteries

Coptic Monasteries

Egypt's Monastic Art
and Architecture

Gawdat Gabra

With a historical overview by
Tim Vivian

The American University in Cairo Press
Cairo New York

To the memory of
Labib Habachi
in deep gratitude

Contents

Illustrations

Maps and Plans

Color Photographs *(between pages 80 and 81)*

Monastery of al-Baramus

Monastery of St. Pshoi

Monastery of St. Antony

Monastery of St. Paul

Monastery of St. Shenute
(The White Monastery)

Preface

In the second half of the twentieth century, especially during the pontificate of His Holiness Pope Shenouda III (1971–), Coptic monasteries experienced a revival of intense interest, providing an impetus for their study and preservation. A number of foreign expeditions became involved in the restoration of monastic paintings that led to the discovery of wonderful new murals. This significant and beautiful heritage is published primarily in specialized periodicals and series. With the increasing number of educated visitors to Coptic monasteries from Egypt and abroad, the lack of an introduction to the sites and their history became increasingly apparent. I hope this book satisfies the needs of such visitors and that students of Coptic Studies, Art History, and related disciplines also will benefit from its content and illustrations.

In writing this book I have incurred debts both institutional and personal. A generous grant from the Aziz S. Atiya Fund, at the University of Utah, freed me to devote myself to the manuscript's preparation. The same source covered the greater part of travel expenses associated with the project, which considerably exceeded expectations. An additional allowance provided by the Dr. Gerda von Mach Gedächtnisstiftung, Berlin, supported my research. I benefited, as always, from the facilities of the Westfälische Wilhelms-University, Münster, Germany, and from the use of the library of the Institute of Egyptology and Coptology in particular. The abbots and monks of many Coptic monasteries alleviated my labors. I am greatly indebted to Dr. Tim Vivian for his excellent contribution on the

history of the Coptic Church and monasticism. I owe special thanks to Dr. Peter Grossmann, whose accurate plans of almost every monastery and church dealt with in this volume enormously enrich the text. Professor Wlodzimierz Godlewski has generously provided the plans and the photographs of the hermitages of Naqlun and the Church of the Archangel Gabriel. The photographs of the wall paintings at the Monastery of the Syrians are courtesy of Dr. Karel Innemée; that of the stucco-work is courtesy of Dr. Mat Immerzeel. I wish to thank Dr. Marianne Eaton-Krauss, who has kindly revised my English. I am grateful to all who gave permission to reproduce illustrations. The text owes much to the editorial staff of the American University in Cairo Press and I would like to single out Mark Linz, director, and Neil Hewison, managing editor, Matthew Carrington, and Andrea El-Akshar for special mention.

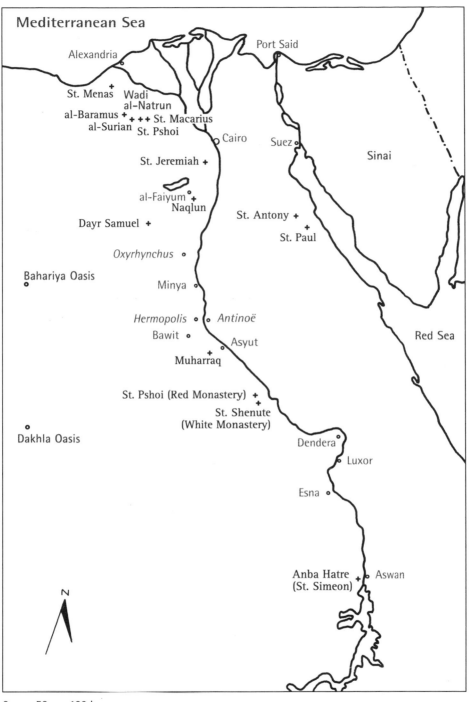

Mediterranean Sea

Alexandria

Port Said

St. Menas
Wadi
al-Natrun
al-Baramus + + + + St. Macarius
al-Surian St. Pshoi

Cairo

Suez

Sinai

St. Jeremiah

al-Faiyum
Naqlun

St. Antony

Dayr Samuel

St. Paul

Oxyrhynchus

Bahariya Oasis

Minya

Hermopolis Antinoë
Bawit Asyut

Red Sea

Muharraq

St. Pshoi (Red Monastery)
St. Shenute
(White Monastery)

Dakhla Oasis

Dendera
Luxor

Esna

N

Anba Hatre Aswan
(St. Simeon)

0 50 100 kms

Coptic Monasteries in Egypt

Introduction

Monasticism represents the most important contribution of the Copts to world civilization. St. Antony of Egypt (251–356) is known as "the father of the monks." His biography, which was written by Athanasius shortly after the saint's death, has influenced the Christian world; it suffices to mention its deep impact on St. Augustine. Egypt is the birthplace of cenobitic, or communal, monasticism. St. Pachom (292–346) established this system of monasticism at Tabennisi in Upper Egypt, based on precise rules that cover almost every aspect of a monk's life, from when he should pray, attend mass, work, sleep, and take his meals to what punishments were to be meted out for infringements. In 404 St. Jerome translated these rules into Latin from a Greek translation, which had been made for him from the Coptic text. In the fourth and the fifth centuries many European travelers visited Egypt to learn and report about monasticism. Some important personalities of early Christianity lived among the Coptic monks in the Egyptian deserts, among them: John Chrysostomus (ca. 347–407), bishop of Constantinople; Rufinus (ca. 345–410), the ecclesiastical historian; Palladius (363–431), author of the *Historia lausiaca*; Basilius the Great (330–379), author of the liturgy; and John Cassianus (ca. 360–435), author of a monastic rule. Thus Egyptian monasticism directly and indirectly influenced European monasticism. The western monastic tradition, in particular the Benedictine order, owes much to the Coptic predecessors.

Monks played a crucial role in the history of Christianity in Egypt and in the continuity of the Coptic Church. St. Antony came to Alexandria with his disciples to support the Christians, who were imprisoned at the time of persecution. During some of his exiles, Patriarch Athanasius (326–373) found refuge in monasteries; he was the first to encourage the consecration of monks as bishops. Monks were actively involved in the dogmatic controversies and participated in the ecumenical councils; St. Shenute, who attended the Council of Ephesus in 431, provides a prominent example. It is reported of the two great figures of monasticism, St. Antony and St. Pachom, that they defended orthodoxy. Shenute destroyed pagan temples in Akhmim, his region. The patriarchs of Alexandria were supported by monks, who often went to the great city and were apparently responsible for the destruction of the famous Serapeum there. Beginning in the eighth century the monasteries of Wadi al-Natrun furnished most of the patriarchs of the Coptic Church from among their monks.

Before the end of the fourth century monasteries rapidly became numerous throughout Egypt. Thousands flocked to the Egyptian deserts to serve an apprenticeship in the art of monasticism. Palladius reported 5,000 monks in Nitria and 600 in Kellia towards 390. At the beginning of the fifth century St. Jerome stated that 50,000 Pachomian monks attended the annual meeting. Sources speak of 2,200 monks and 1,800 nuns under Shenute (d. 464/5) at Atripe, and of 3,500 monks in Scetis ca. 570. Before the Arab conquest of Egypt in 641, hundreds of monasteries flourished throughout Egypt. Although a number of them were sacked by the nomads of the Libyan desert in the fifth century and many monasteries suffered brutal plunder and destruction during the Persian occupation (619–629), the real decline of Coptic monasteries began in 705 when the poll tax was imposed for the first time on the monks. Between the ninth/tenth and the twelfth centuries a large number of monasteries were abandoned; sand covered some of them, preserving their beautiful wall paintings and architectural sculptures for posterity. Subsequent waves of persecution and the confiscation of the monastic

property, especially during the Mamluk Period (1250–1517), led to the gradual abandonment of the majority of Coptic monasteries. By the fifteenth century those which were still inhabited had fallen into a very dilapidated state, so that few monks lived even at the great monastery of St. Macarius in Wadi al-Natrun. Although they suffered from pillage in times of disorder or persecution and were partly ruined and restored several times during many centuries, what remained of the artistic and literary heritage of Coptic monasteries is beyond estimation.

Most aspects of Coptic culture are represented in the monasteries of Egypt. They are the major source for the study of Coptic architecture and architectural sculpture. Almost all Coptic wall painting is monastic. The documents and the *ostraca* from monastic settlements provide invaluable insights into the economic and legal life of the monks and of their non-clerical surroundings. Pottery, wooden, and metal objects discovered in Coptic monasteries shed light on daily life within their confines and demonstrate artistic quality and variation during several periods. The Pachomian monastic rule made literacy obligatory. Some monasteries had *scriptoria*, where copyists were engaged in transcribing manuscripts; important centers were in Upper Egypt, al-Faiyum, and in the Monastery of St. Antony near the Red Sea. Coptic monasteries possessed libraries; some of them were large, as for example those of the monasteries of St. Macarius at Wadi al-Natrun, the Archangel Michael at al-Faiyum, and St. Shenute at Sohag. Monastic libraries served as repositories of Greek, Syriac, Old Nubian, Ethiopian, Armenian, and Arabic as well as Coptic manuscripts. In addition to the intrinsic value of these manuscripts, they provide evidence of the multiethnic character of some monastic communities. Over many centuries monastic libraries preserved Coptic literature and the Christian Arabic literature of the Copts, which are not only significant for the history of Christianity and the Church in Egypt, but also for biblical, patristic, hagiographic, and liturgical studies as well.

This book aims to introduce the general reader to the most important Coptic monasteries, especially those that preserve relatively complete

buildings, so as to demonstrate Egyptian monastic architecture, architectural sculpture, and wall painting at their best. They are located for the most part near other sites that tourists visit frequently. The monasteries of Wadi al-Natrun are about an hour's drive from the pyramids of Giza. The Monastery of the Archangel Gabriel is situated about sixteen kilometers southeast of al-Faiyum. The monasteries of the Eastern Desert, St. Antony and St. Paul at the Red Sea, can be reached in a few hours from Hurghada. The monasteries of St. Shenute and St. Pshoi at Sohag are located about sixty kilometers to the north of Abydos, while further south, the monasteries of Anba Hatre and that at Qubbat al-Hawa are situated on the west bank opposite Aswan. The monasteries of St. Apollo at Bawit and St. Jeremiah at Saqqara are chosen from among the ruined monasteries for their beautiful older sculptures and wall paintings, which are exhibited in the Coptic Museum, Cairo. The characteristic elements of each monastery have been chosen to provide together a synoptic view of Coptic monasteries.

Some significant monasteries and monastic settlements or hermitages are not included in this book, for different reasons. One example is the site of Kellia, which disappeared almost completely not long after its discovery as a result of the encroachment of the cultivation into the Libyan desert near the Delta. Also, the renowned Monastery of St. Catherine at Mount Sinai is excluded, for it retained its Greek character in every respect throughout the centuries although located on Egyptian soil. Some monastic churches are decorated with icons; none of them will be described in this book since information about their provenance is lacking.

The last two decades have witnessed remarkable progress, with many new discoveries in the field of Coptic monastic painting. Cooperation between the Supreme Council of Antiquities (formerly the Egyptian Antiquities Organization) and some foreign expeditions have proven very fruitful. Modern methods of documentation, conservation, and restoration were applied in a number of Coptic monasteries, especially by the French and Dutch expeditions at the monasteries of al-Baramus

and the Syrians at Wadi al-Natrun, by the Polish expedition at the Monastery of the Archangel Gabriel at Naqlun, by the American expedition at the Monastery of St. Antony near the Red Sea, and by the French and the Dutch expeditions at the monasteries of St. Shenute and St. Pshoi at Sohag. While these new discoveries were reported in preliminary reports in various periodicals, most went unmentioned in the Coptic Encyclopedia that appeared in 1991. Needless to say, only a selected bibliography can be provided here for each site; however, the most recent publications available to me are included. It is well known that in some of the monasteries, especially in that of the Syrians at Wadi al-Natrun, more wall paintings can be expected to come to light in the years ahead as the result of ongoing restoration work.

An introductory essay on the history of the Copts, the Coptic Church, and monasticism is intended to facilitate the reader's appreciation of the environment and the age from which these monasteries originate. I have kept the use of the technical terms to a minimum; those which occur appear in italics and are explained either immediately in the text or in the glossary.

Chronology

(30 BCE–1849 CE)

30 BCE

Egypt became a province of the Roman Empire.

ca. 50–60 CE

St. Mark the Evangelist in Alexandria. According to tradition, he founded the Church in Egypt.

ca. 180

Theological college (Catechetical school) at Alexandria founded.

202

Emperor Septimius Severus: edict forbidding people to become Christians and the first major persecution of Egyptian Christians.

189–231

Demetrius, patriarch of Alexandria, consecrated three bishops in Egypt.

249–260

Wider persecution of the Christians under the emperors Decius (249–251) and Valerian (253–260). The former issued a universal order to sacrifice to the gods; the penalty for refusal was torture and death.

284–313

Emperor Diocletian: the most severe wave of persecution of Egyptian Christians began during his reign and continued under Emperor Maximinus (305–313). The accession of Diocletian (284) marked the

beginning of the Coptic calendar "Era of Martyrs." Diocletian founded the Fortress of Babylon.

313

The Edict of Milan recognized the legal status of the Christians.

ca. 320

St. Pachom founded cenobitic, or communal, monasticism at Tabennisi, and established "Pachomian" monastic rules.

325

The Council of Nicaea condemned the doctrines of Arius and formulated the Creed of Faith.

330

Byzantium (Constantinople) became the capital of the Byzantine Empire. ca. 330: St. Macarius and the beginning of the hermitic settlements at Wadi al-Natrun.

373

The death of Patriarch Athanasius (326–373), the greatest and most consistent theological opponent of Arianism.

392

Under Theodosius the Great Christianity declared official religion of the Byzantine Empire.

431

The Council of Ephesus condemned Nestorius.

451

The Council of Chalcedon condemned the Monophysite doctrine (Christ's One Nature Theology). The Dyophysite doctrine (Christ's Two Natures Theology) was rejected by the Egyptians and the Coptic Church became a national church.

619–629

The Persian occupation of Egypt during which many monasteries were destroyed.

641–644

The Arab conquest of Egypt: the Arab general 'Amr ibn al-As captured Alexandria and established a new capital, al-Fustat, to the north of the Fortress of Babylon.

661–750

Damascus was the capital of the Arab Islamic Empire. The poll tax was imposed for the first time on the monks.

750–969

Baghdad was the capital of the Abbasid dynasty. The desperate economic state of the Copts led them to revolt against taxes. The Bashmurite rebellions in the Delta were ultimately quashed by the Abbasid Caliph al-Ma'mun himself in 830. Under the Tulunid and the Ikhshid dynasties (870–969) Egypt became independent and the Copts occupied the most important positions in the administration of the country.

969–1171

The Fatimid rulers founded Cairo in 969. Under their rule the Copts enjoyed a fair amount of religious liberty and were employed in high government positions. An exception was the era of al-Hakim (996–1021), who destroyed many churches and monasteries. The Copts were dismissed from the government administration, humiliated, and their goods were plundered. Their numbers began to decline through conversions to Islam. After the death of al-Hakim the Copts restored old churches and built a large number of new ones.

1171–1250

Salah al-Din (Saladin) (1171–1193) founded the Ayyubid dynasty and built the Citadel on a hill northeast of Cairo. His intolerant attitude towards the Copts changed after he captured Jerusalem in 1187.

However, the relations between the Copts and their Muslim rulers were influenced by the progress of the Crusades. This period is characterized by a renaissance in the art of the Copts, especially in monastic painting.

1250–1517

Under the Mamluke sultans the Copts suffered sporadic violence and continuing persecution. Their goods were plundered and their properties were confiscated. Coptic employees were often dismissed. Occasionally, the Copts were compelled to wear blue turbans and ride asses instead of horses. On May 8, 1321, most Coptic churches were destroyed. The Coptic community was diminished considerably through conversion of its members to Islam. The Coptic language was used only for the liturgy, while the Christian Arabic literature of the Copts flourished.

1517–1849

Egypt became a province of the Ottoman Empire. Most Egyptians, Muslims and Copts, lived in misery because of the burden of taxes imposed on them. Churches were often closed, to be reopened only after the Copts had paid the required ransom. The majority of Coptic monasteries were abandoned. In the second half of the eighteenth century some Copts were called upon to hold high positions in the administration of the country. This led to restoration, renovation, and construction of Coptic churches. During the reign of Mohamed Ali (1805–1849), a by-product of Bonaparte's expedition (1798–1801), Egypt was modernized and the Coptic community flourished.

The Coptic Orthodox Church
by Tim Vivian

The Meaning of the Term "Copt"

The word "Copt" reflects in miniature the history of the Coptic people of Egypt. The term appears to derive from the Greek *aigyptos/aigyptioi*, which was later reduced in Arabic to *qbt*, and thus gave rise to the word "Copt" or "Coptic" designating both the country of Egypt and its native inhabitants. (In the Coptic language itself, the late written form of ancient Egyptian, "Egypt" is designated by *chêmi*, literally "the black land" (from *chmom*, "black"), probably referring to the rich black silt of the Nile, and "Egyptian" is *remnchêmi*, "person of Egypt.")

The Greeks appear to have formed *aigyptos* from the name of the principal Egyptian sanctuary in Memphis; thus the name encapsulates both ancient Egyptian geography and religion going back to the time of the pharaohs and the influence of the Greeks, who settled in Egypt as early as the seventh century BCE and who, under Alexander the Great, conquered the land in 332 BCE. Almost 1,000 years later, in 641 CE, Muslim Arabs wrested Egypt from Roman-Byzantine control. Egypt thus became, over time, a predominantly Muslim, Arabic-speaking country, and the name of its people was likewise changed from the Greek *aigyptos* to the Arabic *qbt*.

The word "Copt," then, began as a geographical and ethnic designation. Later the term came to distinguish the native inhabitants of Egypt, the vast majority of whom were Christians, from the Arabs, who were Muslim. Thus the word came to have religious connotations. This became

increasingly true from the ninth century onward as many Christians converted to Islam and the Copts became a minority in their own country. The word "Copt" came, therefore, to mean "Egyptian Christian." Historians, however, also speak of a "Coptic" period of Egyptian history from the second to the seventh century. Thus the term must be understood somewhat elastically, in a historical, social, ethnic, and religious sense.

History of the Coptic Church

The head of the Coptic Orthodox Church is called "the Pope of Alexandria and the Patriarch of the See of St. Mark." Just as Roman Catholic tradition believes that Sts, Peter and Paul founded the See of Rome, Coptic tradition firmly asserts that St. Mark the Evangelist came to Alexandria in the first century and established Christianity in that great Greek city. Modern historians have been unable either to prove or disprove this assertion. It seems reasonably certain that the earliest Christianity in Egypt (that is, in Alexandria) was Jewish-Christian in nature, which was common in much of the early Church. Deeper than history, at least in the hearts of the Coptic faithful, is the belief that the Holy Family, fleeing the wrath of Herod the Great, escaped to Egypt and lived there for three years, during which time the infant Christ performed a number of wondrous deeds. Coptic tradition also locates numerous Old Testament patriarchs and prophets in Egypt. One can see from these traditions—the patriarchs and prophets, the Holy Family, St. Mark—that the Coptic Church understands itself to be a Church founded upon the prophetic and living word of scripture.

The first bishops of the See of Alexandria, which would later become the Coptic Orthodox Church, are only names on a list; virtually nothing is known about them. The first great figures of the Church in Egypt were, in fact, scholars rather than bishops, leaders of the Catechetical School of Alexandria: Clement of Alexandria (160–215) and Origen (185–251). (It must be noted that the best known figures of the earliest period in Alexandria are in fact Gnostics: Basilides, Valentinus, and Carpocrates.)

Both Clement and Origen integrated Greek thinking and philosophy, espe-
cially Platonism, with biblical theology. Clement presented Christianity as
the true philosophy and argued that the Christian was the true gnostic, or
person who knows God. Origen, a much greater intellect, was perhaps the
most prolific writer in antiquity: he wrote homilies, commentaries on the
Bible, and apologia. Origen was above all a biblical theologian, as Robert
Daly has put it: "committed to handing on the Church's rule of faith by
expounding the many ways in which the eternal Word is *now* incarnate—
i.e., present and speaking to us—in the word of scripture." For Origen, all
scripture had a spiritual meaning and pointed to Christ. This spiritual
reading of scripture was to profoundly influence later theologians such as
St. Gregory of Nyssa and the monastic tradition beginning with St.
Antony the Great. Clement and Origen emphasized spiritual discipline,
spiritual growth, and the education of the soul, teachings that would help
shape monasticism at the end of the third century and on into the fourth.

Origen's father died as a martyr and he himself was tortured in 250
during the persecution of Christians by Emperor Decius. Bishop
Dionysius, who fled his see in Alexandria, reported that numerous
Christians had died during this persecution. In 284 Diocletian became
emperor. Later, he instigated the Great Persecution (303–311), which
caused the death of hundreds, perhaps thousands, of Christians. Egypt
was particularly hard hit and suffered the death of its bishop, Peter I of
Alexandria, in 311. The Church in Egypt became the "Church of the
Martyrs," beginning its calendar with the year of Diocletian's accession:
AM 1, *anno martyrorum*, "the year of the martyrs." St. Antony the Great
was born during the Decian persecution (251) and later went to
Alexandria to confess his faith during the Great Persecution.
Monasticism did not have its first full flowering until after the Great
Persecution had ended and Emperor Constantine had ushered in the
"Peace of the Church" in 313, but monasticism has roots both in Origen's
ascetic spirituality and the heroic Christianity which he and scores of
nameless Egyptian martyrs demonstrated.

Christianity did not grow systematically and regularly in Egypt, but undoubtedly followed the Nile south from Alexandria. By 313 there were about seventy-two bishops in Egypt, Cyrenaica, and Libya, and by 325 there were almost a hundred. The fourth and fifth centuries became perhaps the greatest centuries of the Church in Egypt, witnessing not only great episcopal leaders and theologians like St. Athanasius the Great (300–373) and St. Cyril of Alexandria (375–444), but also, and just as importantly, the founding of monastic communities in Nitria, Kellia, and Scetis (Wadi al-Natrun) in the 330s and the emergence of such preeminent monastic figures as St. Antony the Great (251–354), St. Macarius the Great (300–390), St. Pachomius (292–346), and St. Shenute the Great (385–465).

Athanasius and Cyril, two of the greatest theologians of the early Church, brought the Church of Alexandria to preeminence in the fourth and fifth centuries. Athanasius fought tirelessly on behalf of the Creed, established by the Council of Nicaea in 325, asserting the true divinity of God the Son. In this struggle he was pitted primarily against Arius, who argued that Christ was not eternally with God the Father but was the first of all created things. For Athanasius, only Christ as part of the eternal Trinity could absolve humanity of its sin, so the issue for him was soteriological (related to human salvation). "God (*theos*) became human," Athanasius said, "so we humans might become divine (*theopoiêthômen*)." Athanasius was not only a skilled theologian but also effectively cemented the alliance between monasticism and the See of Alexandria, an alliance that would later benefit Cyril greatly.

Cyril was arguably an even mightier polemicist than Athanasius. His main opponent was Nestorius, who argued that the term "Theotokos," or Mother of God, should not be applied to St. Mary because she was the mother of only the humanity of Christ. In response, Cyril systematically formulated the classical Greek doctrines of the Trinity and the Person of Christ. Arguing against what he saw as Nestorius' attempt to divide the person of Christ, Cyril stressed the integrity of the Logos and argued that, in the union of the divine and human in Christ, the divine nature was pre-

eminent over the human. For him, there was only one *hypostasis* (person), that of the Logos, which assumed a whole and complete humanity. There are indeed two natures in Christ, Cyril conceded, but only *before* the union of the divine and the human. At the moment of union, however, there is only one nature, that of the incarnate Logos, in which the characteristics of humanity and divinity are united in a single subject, Jesus Christ. The emphasis of Cyril—and of Athanasius and the Alexandrian tradition—on the union of natures in Christ would ultimately lead the See of Alexandria to break from the Sees of Rome and Constantinople.

That rupture came in 451 after the Council of Chalcedon accepted the tome that Leo, Bishop of Rome, offered, which asserted that there were two natures in Christ. The formula of Chalcedon was actually a compromise between the Monophysites and Dyophysite, but like many compromises where passions are heated (and ecclesiastical rivalries are involved), it did not hold. The opposition to Chalcedon in Egypt was largely led by the monks, who represented the Coptic populace and voiced its resentment of oppressive foreign (that is, Byzantine) rule and Greek cultural hegemony centered in Alexandria. After 451 there were essentially two Churches in Egypt, often with two opposing patriarchs, one Greek and one Coptic. This religious civil war enervated the country and left it weak and exposed when, in 641, a small Arab army invaded Egypt and quickly conquered it, bringing a sudden end to the Byzantine era. The Byzantine Empire centered in Constantinople managed to survive another eight hundred years, until 1453. But the Coptic Orthodox Church, now isolated both religiously and politically from Rome and Constantinople, found itself alone less than one hundred years after the death of St. Antony.

The Egyptian Church now became a national Church, one that increasingly used Coptic as its liturgical, biblical, and theological language. Two groups confronted each other, often with hostility, sometimes with violence: Melkite Christians (those who supported Chalcedon, usually Greek-speakers), and the Monophysites (who opposed Chalcedon and who were usually Coptic-speaking). This conflict, of course, had an

effect on the monasteries of Egypt. The monastic community of Kellia, west of the Nile Delta, physically illustrates the schism between Melkites and Copts. Before 451, archaeological evidence demonstrates, Kellia had one church; after the middle of the fifth century, it had two—one for each side of the Chalcedonian schism. Each church had its own baptistry, possibly for baptizing converts from the other side. Kellia came to be a community quite literally divided against itself.

After Chalcedon, Alexandria remained Melkite, while the monasteries and the countryside were Coptic Orthodox. W.H.C. Frend has commented that, "The loss of Alexandria to the Chalcedonians had the effect of polarising differences between an 'imperial' or 'Melkite' church in Alexandria and the 'Coptic' or 'Monophysite' church in the remainder of Egypt, whose center was now the monastery of St. Macarius," southwest of the Delta. The divided nature of the Church in Egypt was reflected also in the monasteries. The Pachomian monastery of Metanoia at Canopus in Lower Egypt had Melkite leanings while the Pachomian monasteries in Upper Egypt remained anti-Chalcedonian until the time of Justinian. In 516, the people of Alexandria rioted against Emperor Anastasius' choice of patriarch. The pro-Chalcedonian policies of Emperor Justinian I (527–565) caused havoc in the Pachomian monasteries and apparently precipitated the breakup and demise of the Pachomian *koinonia*. St. Shenute had provided the Copts with a popular base that was never lost, though it was probably not until the early seventh century that the monks regarded themselves "consciously as both Egyptian and anti-imperial." *The History of the Patriarchs* asserts that during the reign of Peter IV (567–579) there were "six hundred flourishing monasteries, like beehives in their populousness. . . where all the people held the true faith." Late in the sixth century, John, Bishop of Shmun and a monk, wrote an encomium on Antony in which he patriotically praised Antony as both the father of monasticism *and* the father of Egypt, and extolled Egypt's greatness. In 631, Emperor Heraclius sent Cyrus (al-Muqawqas) to Egypt. Cyrus tried to unite the Melkites and Coptic Orthodox Church by force, but Dayr Metras, the

monastery residence of the Coptic Orthodox patriarch, refused to accept Chalcedon. By the seventh century, before the Arab invasion in 641, Egyptian monasticism "was the heart and soul" of the Coptic Church.

Three years after Alexandria fell to the Arabs the Coptic patriarch Benjamin I returned to the city from an exile which had been imposed by the Chalcedonian Byzantines. The Copts at first enjoyed greater financial and religious freedoms under the Muslims than they had under the Byzantines; they were no longer considered heretics but were now *dhimmis*, protected non-Muslims. The Copts also played a vital and important role in government. The Copts were, nevertheless, still a subject people and were assessed an annual poll tax. They also suffered second class citizenship, social restrictions, and, eventually, persecution. During the first century after the conquest Copts continued to make up the vast majority of the population of Egypt. In the next two centuries virtually all the patriarchs of the Coptic Orthodox Church would come from the monasteries, almost all of them from the Monastery of St. Macarius in the Wadi al-Natrun.

During the eighth and ninth centuries the Copts began their decline to a minority people. Coptic revolts were crushed twice in the eighth century, a period that also saw major migrations of Arabs into Egypt. In 831 the Bashmurite revolt was put down, and a great wave of conversions of Copts to Islam apparently followed; by the end of the ninth century Copts were a large minority in Egypt and the percentage of Copts quickly decreased in the opening decades of the tenth century. Coptic remained the liturgical language of the Church but since Arabic was now the language of government and business, more and more Copts became primarily Arabic speakers. For the next century the Coptic patriarchate suffered an annual tax of 1,000 dinars. As a result of this financial burden simony, or the selling of ecclesiastical offices, was common until Pope Abraham (975–978) got the tax reduced and instituted reforms.

Throughout the following centuries, the fortunes of the Copts and their Church ebbed and flowed depending on who their rulers were.

Under Salah al-Din (the famous Saladin of the Crusades), for example, Christians in Egypt were subject to severe social and ecclesiastical restrictions. The monasteries in general declined during this period, although they continued to supply most of the Church's bishops and patriarchs. The thirteenth century witnessed the flowering of Copto-Arabic literature, which continued on into the Mamluk period. During the fourteenth century, however, conversions to Islam increased and even regions like Upper Egypt, which had remained predominantly Christian, became mostly Muslim.

Under the Ottomans (1517–1798) the Church continued to have difficulties; it has been estimated that at the end of the seventeenth century there were only about 150,000 Coptic Christians. In the half century after 1661, the monasteries were also in serious decline: St. Antony's dwindled from fifty monks to fifteen, St. Macarius' from twenty to four, and St. Bishoi's from twenty-four to five. With the Church in decline, the first great modern reform came under Pope Cyril IV (1854–61), who stressed education for the clergy and adherence to traditional liturgical practices. By the end of the nineteenth century, the Coptic Church was considerably stronger than it had been for centuries.

During the twentieth century the Church went from strength to strength. The most striking development in the twentieth century was the growth of the Coptic diaspora; there are now about eight million Copts in Egypt and perhaps one million outside the country; these latter reside principally in Britain, Canada, Australia, and the United States. The two great leaders of the Coptic Church in the 20th century have been Pope Cyril VI (1959–71) and Pope Shenouda III (1971–present). They have led a renaissance of the Church: the Sunday School movement to improve Christian education; the Rural Diakonia Program to serve Coptic families in villages that have no church; the use of "general bishops" (those without a diocese) to oversee special areas such as education, ecumenism, and social service; and, not least, the rebirth of the monasteries and monasticism.

Father Abd al-Masih (Slave of Christ), the Ethiopian, lived as an ascetic for thirty years in a remote sandstone cave; more importantly, he deeply influenced Mina al-Muttawahad (Mina the Hermit), who became Pope Cyril VI, Antonius al-Suriani, who was to become Pope Shenouda III, and Father Matta al-Meskeen, a great spiritual writer and teacher who helped revitalize the Monastery of St. Macarius. Thirty or forty years ago, Coptic monasticism was in serious decline, with falling numbers, an aging population, and crumbling buildings. In 1960, nine major monasteries contained 200 monks. By 1986 that number had risen to 600, a three-fold increase. In addition, in Upper Egypt two new monasteries have been officially recognized by the Church, and, according to Otto Meinardus, "formerly abandoned monasteries... have been repeopled with monks." In the last twenty-five years, all the monasteries of Wadi al-Natrun have undertaken large-scale building projects, including large new dormitories for the increased number of monks. More importantly, the monasteries have built new retreat centers and implemented evangelical programs. With the increased numbers of monks, a renewed spirit, and—not unimportant—improved roadways linking the monasteries with cities and towns, the monasteries have gone from a position of hanging on for mere survival to one of active participation in the Coptic Church as a whole. Despite being a minority faith within Egypt, with these changes, and now with the vibrant life of its people throughout the world, the Coptic Orthodox Church can look to the twenty-first century with great hope and promise.

Rites and Ceremonies of the Coptic Church

The dogmas and sacraments of the Coptic Orthodox Church are nearly identical to those of the other Orthodox Churches. Although the language of the Church has been Coptic (with some Greek), the orthography of the Coptic inscriptions in the Old Church at the Monastery of St. Antony show that the main language of the writers early in the thirteenth century was no longer Coptic but Arabic. Arabic is now the pre-

dominant liturgical language and has been for almost a thousand years. In the Coptic diaspora, however, especially in English-speaking countries (England, Australia, Canada, the United States), English is becoming increasingly important, and the Coptic *Liturgy of St. Basil* and the *Agpia*, the monastic *Prayer Book of the Seven Canonical Hours*, are now all to be found in English. As in the Greek Orthodox Church, instruments are not used to accompany the chants and hymns of the Divine Liturgy, though cymbals and triangles are used with some hymns and chants.

The Church uses seven canonical hours of prayer, which evolved from monastic usage and will be familiar to many Christians in the West: Prime (also called the Prayer of the First Hour and Morning Prayer), Terce (Third Hour), Sext (Sixth Hour), None (Ninth Hour), Vespers (the Prayer of the Eleventh Hour or the Sunset Prayer), Compline (Twelfth Hour), and the Midnight Prayer. Monks also say the Prayer of the Veil, which is read daily in monasteries after the Twelfth Hour and before Midnight Prayer. This cycle of prayer begins roughly at six a.m. or dawn (changing according to the season), and procedes at intervals during the day. Monks will recite the entire Psalter, or collection of Psalms, each day.

The Coptic Church has traditionally used three liturgies: that of Cyril of Alexandria, that of Basil the Great, and that of Gregory of Nyssa. The liturgy of Cyril is the most ancient of the three, incorporating material from the liturgy of St. Mark. It was used until the fifth century. The liturgy of Basil is used throughout the year, while that of Gregory is reserved for the Nativity, Epiphany, and Easter. Church services on Sundays and feast days are the Evening Offering of Incense, preceded by None, Vespers, and Compline, and the Morning Offering of Incense, preceded by Matins and Prime and followed by Terce, Sext, and the Divine Liturgy. The time of the Liturgy varies between six and nine in the morning. For the Holy Eucharist, the Copts use freshly baked leavened bread made from flour and yeast (salt is not used) and wine made from raisins. Communion is administered in both kinds: the Holy Body is placed in

the communicant's mouth and the Precious Blood is offered by means of a spoon, as in other Orthodox Churches. Fasting is required before receiving Communion.

Monasticism

Origins

Monasticism has its origins in the Bible, in Old Testament prophetic figures such as Elijah and Isaiah ("The voice of one crying out in the wilderness (*erêmos*): 'Prepare the way of the Lord, make his paths straight'"; Is 40:3–5) and, in the New Testament, in John the Baptist, a wilderness figure (Lk 3:2), living on the margins of society and calling on society to repent (Lk 3:3). Jesus, after his baptism, was led—or was driven—by the Spirit into the same wilderness or desert (*erêmos*), where he was tempted by the Devil (Lk 4:1–13) and to which he would often return to pray in solitude (Lk 4:42). More than being tied to place, however, monasticism is founded on the Gospel precept proclaimed by Christ: "If you want to be perfect, go, sell all your possessions and give to the poor, and come follow me, and you will have treasure in heaven" (Mt 19:21).

The New Testament also has a strong ascetic impulse (the word "ascesis" originally meant "training"), behind which lies the belief that this world is not the ultimate reality (2 Cor 4:18); in fact, this world, with its pomp and circumstance, can be a hinderance to living a life in God. Therefore, the preoccupations of this world—food, dress, money, honors, sex—are, more often than not, distractions that draw one away from God. Ascetic disciplines such as abstinence, fasting, poverty, prayer, and vigils are means to help keep one's attention focused on God. Early Christian asceticism, which was not solitary, looked back to the communalism found in Acts 4:32 as the ideal for the Christian life: "Now the whole group of those who believed were of one heart and soul, and no one claimed private ownership of any possessions, but everything they

owned was held in common." Early Christian monasticism also had relatives in Judaism (the Essenes of Qumran fame and, in Egypt, the Therapeutae, whom the Church historian Eusebius of Caesarea mistakenly regarded as Christians) and in Stoicism, but it seems now that these were more like distant cousins than grandparents.

The word "monk" comes from the Greek word *monachos* and means "solitary." The first known monk, however (that is, the first ascetic known as a *monachos*), was not a solitary but, rather, was a village monk, one of the *apotaktikoi* or "renunciants." A papyrus dated to 324 CE cites a *monachos* named Isaac, along with a deacon named Antoninus. In this papyrus, a certain Isidore complains to a government official that a neighbor's cow had damaged his crops. Isidore caught the cow and was bringing it to the village when his neighbor, along with a companion, met him in the fields with a big club, threw him to the ground, rained blows upon him, and took away the cow. Isidore goes on to complain that these two brutes "would have finished me off completely" had it not been for the deacon Antoninus and "the monk" Isaac who happened by and rescued him.

It is clear from this complaint that Isaac was not a solitary man out in the desert, but was in some way associated with the village, strolling along with the deacon Antoninus. Isidore matter-of-factly uses Isaac's title, *monachos*, which suggests that it was a commonly used term by 324. Isaac was probably a village ascetic, rather than an anchorite (from Greek *anachôrêsis*, meaning "one who withdraws"), and he points towards the origins of cenobitic monasticism. There was apparently an early apotactic (renunciant) movement that was centered not in the desert but in the cities and villages of the Roman Empire, a movement that preceded both the anchoritic (solitary) and cenobitic (communal) forms of monasticism. Monks like Isaac, one should note, look back to the way of life established by the widows and virgins of the early Church who lived lives of personal renunciation in service to the Church. Isaac's withdrawal, it is important to stress, was not spatial (into the desert) but social (away from the norms of marriage and family). Later, in the writ-

ings of Antony, withdrawal came to mean separation from people, out into the desert. Even later, in such writers as Jerome, Antony's type of monasticism came to represent the norm, and village ascetics like Isaac were either forgotten or deemed "irregular" and suspicious.

Monasticism seems to have arisen almost simultaneously in Egypt, Palestine, and Syria and, as represented by the widows, virgins, and village ascetics, was originally communal. Later, with anchoritic figures like Antony, it became solitary (while, it should be noted, existing side by side with more communal forms), more closely representing the etymological origins of the word "monk." finally, in Egypt, Palestine, Asia Minor (under the guidance of St. Basil the Great), and in the West, especially under St. Benedict, monasticism became less solitary and more communal; the monastery (*monastêrion*), which originally meant "cell," evolved into a village. According to Otto Meinardus, a modern Egyptian monastery gives this impression: "from the walls one looks down into the monastery which looks like a typical Egyptian village with mud brick houses, narrow streets, numerous churches, gardens, palm trees, and water channels." Thus monasticism includes both the solitary and the communal. Its origins, it seems, are communal, but its vocabulary ("monk," "monastery") is solitary. At its best, it combines both aspects. In the words of Antoine Guillaumont, "la vie solitaire et la vie communitaire" ("solitary and communal life").

St. Antony and the History of Early Monasticism

Antony of Egypt (251–356) is one of those larger than life figures who may well have been as large during his life as after his death, when he was quickly immortalized and canonized by Athanasius in the *Life of Antony*. His call to the ascetic life, thanks to Athanasius' telling, is one of the best known of such experiences from late antiquity, second perhaps only to St. Augustine's account of his conversion in the *Confessions* (the *Life of Antony* in fact helped bring about Augustine's conversion). Six months after the death of Antony's parents, when,

according to the *Life*, he was around eighteen or twenty years of age, Antony heard in church the Lord's command to "sell all your possessions and give to the poor, and come follow me, and you will have treasure in heaven" (Mt 19:21). He left the church, sold his possessions, gave the money to the poor, and entrusted his sister to women consecrated as virgins (*Life* 2.2–3.1).

Antony was not the first monk; the *Life* itself tells us that: in addition to the virgins, "there was at that time an old man in the neighboring village; from his youth he had practiced the solitary life of an ascetic. When Antony saw him, he emulated him in goodness. So Antony too began by at first remaining in places outside that village" (3.3–4). According to the *Life*, then, Antony started out as a village ascetic; he practiced asceticism first outside his village, then in a tomb, and next in a deserted fortress. Around the year 285, after living ascetically for about fifteen years near home, Antony "set out for the mountain," Mt. Pispir, east of the Nile (present-day Dayr al-Maimun, just south of al-Kuraimat), about 75 kilometers south of Memphis, halfway between present-day Itfih and Beni Suef. Here he lived in a deserted fort, which was to become his "outer mountain" (*Life* 11.1). After living as a solitary there for twenty years, Antony emerged around 305–6 to instruct the crowds that came to him in the ascetic life. Finally, around 313 Antony, feeling hemmed in, resolved to push further into the desert. While waiting on the banks of the Nile for a boat to take him south to the Thebaid, he had a vision instructing him to follow some Saracens into "the interior desert," at the foot of a "very high mountain."

This "mountain" was Mt. Colzim (Qulzum), the site of the present-day Monastery of St. Antony. In Egypt, the Nile is the center of geography. Away from the river is desert, and beyond that is the "further" or "remoter" desert, where Antony now chose to live. Although the Nile is in the center of the country, to move away from it is to journey not to the exterior, as we would think, but to the interior, to the desert. The early monks saw this interior wilderness as both a geographical and spiritual reality, a

place where they confronted the aridity of the earth and of the heart. But in this desert the monk, as the new Adam and Eve, also found paradise regained. In this interior Antony found a water source and a cave and prepared a garden. Antony was to spend the rest of his life at Colzim, journeying back and forth between Colzim and Pispir. He died in 356.

While living on the inner mountain (Mt. Colzim), Antony would make frequent visits to Pispir to minister to the monks and crowds at the outer mountain (Mt. Pispir). According to the *Life*, Antony was much sought after for counsel, healing, and even legal mediation. Athanasius portrayed him as a wonder worker, healer, and seer. Monastic tradition independent of the *Life* reports that around 338 Antony, along with Amoun of Nitria, founded the monastic community of Kellia (Cells), between Nitria and Scetis (Wadi al-Natrun), about halfway between modern Cairo and Alexandria. Antony, and the monastery that still bears his name, are part of the phenomenon of fourth-century Egyptian monasticism. Around 330, when Antony was living on the inner mountain, St. Macarius of Egypt founded a monastic community in Scetis. Around 320 Pachomius founded the first community of his *koinonia* at Tabennisi in Upper Egypt. According to Jerome, around the year 400 "nearly 50,000 monks took part in the annual meeting of Pachomian monks." The *Historia Monachorum* reports that there were 10,000 monks at Oxyrhynchus in the fifth century; though the numbers may be exaggerated, Oxyrhynchus does seem to have been a monastic town. Shenute may have led as many as 4,000 male and female monastics.

Such numbers seem as astounding today as they did in the fourth and fifth centuries, although for different reasons. Why did so many people, both men and women, embrace the monastic life? Athanasius, in the *Life of Antony*, clearly understands Antony's call and life as a response to the commandments of scripture; as Adalbert de Vogüé has concluded, "Athanasius sees in Antony's asceticism a discipline whose origins lie in Holy Scripture and in that alone." Such a basic answer has been challenged recently by historians who emphasize economic, political, and

sociological motives; such factors undoubtedly contributed to monastic *anachôrêsis*, but as Armand Veilleux has pointed out: "all the motivations that [the monks] themselves revealed to us in their writings came from Scripture. Do we have a right to pretend we know their secret motivations better than they did?"

The Monasteries of Wadi al-Natrun (Scetis)

Widespread monasticism in Lower Egypt in the fourth century may have had its origins, oddly enough, in two unconsummated marriages. Around 313, shortly after Constantine had brought an end to state persecution of Christians and ushered in "the peace of the Church," a young Christian named Amoun (mentioned above), living in the Nile Delta, was forced by his uncle to marry. On his wedding night, however, he persuaded his wife that they ought to live together not as husband and wife but as brother and sister, devoting themselves to the Lord. She agreed, and they lived this way for eighteen years before he was called to the solitary life of a monk. Around 330, he left his home and "went to the inner mountain of Nitria," forty miles south of Alexandria and west of the Delta, and "built himself two rounded cells and lived another twenty-two years in the desert." Attracted to his way of life, disciples soon joined Amoun, and monasticism began to flourish in Nitria.

Within ten years, Nitria had become too crowded for Amoun, so he and St. Antony together founded Kellia, the Cells, about 10–12 miles south of Nitria. Once when Antony visited Amoun, the latter told him that because of his prayers the number of brothers at Nitria was increasing and some of them wanted cells where they could live in peace (that is, farther away from other monks). So Antony advised Amoun that after they ate at the ninth hour (around three p.m.) they should go out into the desert and look for a new location. They walked until sunset, prayed, and planted a cross to mark the new community. They picked this spot so the monks at Nitria could visit those at Kellia after the afternoon meal. "If they do this," Antony said, "they will be able to keep in touch with

each other without distraction of mind." Kellia, therefore, became a sort of "graduate school" for monks; after some time at Nitria, those who wished for greater solitude, like Evagrius of Pontus, could then move to the cells. The above quote, however, underlines the continued desire for community and concourse. The *Life of Antony* 60.3 adds that the journey from Nitria to Antony's inner mountain took thirteen days and demonstrates that there were already ties between the northern monastic communities and Antony's. The *Apophthegmata*, or *Sayings*, of the desert fathers and mothers also reports visits to Antony by Amoun and Macarius the Great, the founder of monasticism in Scetis (Wadi al-Natrun). Later monastic tradition remembered Amoun of Nitria with such reverence that Antony "saw his soul borne up to heaven by angels."

The threat of forced marriage apparently brought St. Macarius the Great to the desert of Scetis, forty miles south of Nitria at about the same time as Amoun was establishing desert monasticism to the north. Already a monk, Macarius fled to an unnamed village in order to avoid ordination. A young woman in the village became pregnant and, when she was asked "who was to blame," identified "the anchorite"—Macarius—as the father. When the time came for Macarius' "wife" to deliver, she was unable until finally she confessed that she had lied and that Macarius was not the father. When the villagers found out, they repented and went to Macarius to "do penance." But when Macarius "heard this, for fear people would disturb" him, he "got up and fled to Scetis." By the time of Macarius' death in 390 there were four flourishing monasteries in the Wadi al-Natrun: Macarius, Bishoi, John the Little, and the Monastery of the Romans, three of which (the Monastery of John the Little ceased to exist in the fifteenth century) thrive today.

The Pachomian Koinonia

Early monasticism in Scetis (Wadi al-Natrun) was semi-anchoritic: monks lived alone or in small groups of no more than four or five in cells scattered throughout the desert and came together only on Saturdays and

Sundays. In Upper Egypt, by contrast, Pachomius (292–347) founded cenobitic monasticism (in which the monks live together communally). At the time of Pachomius' death there were approximately 5,000 monks living in nine monasteries (there were also two convents), the most notable of which were at Pbow and Tabennisi. At the head of the *koinonia* was a father, to whom the superior of each monastery reported, along with his assistant and a steward, in charge of material needs. Pachomius himself was the father of the *koinonia* until his death. Each monastery in turn had its own father and assistant whose responsibilities were to offer scriptural instruction and spiritual catachesis (teaching) to the monks as well as to oversee the material well-being of the brothers.

The monks at each monastery were divided into houses of about forty brothers each with each house having its own service or ministry (*diakonia*). Some of the larger monasteries had thirty or forty houses. In addition to receiving instruction from the superiors of the monastery, the monks gathered in the morning and evening for common prayer. They spent the rest of the day much as their semi-anchoritic brothers in Scetis: at work and in prayer, reciting scripture that they had learned by heart. Everything was held in common. Twice a year, at Easter and at the end of the Coptic year, all the monks gathered at the central monastery of Pbow. Thus life at the *koinonia* was communal and centered on God.

The End of the First Golden Era

By 330 Egypt was becoming recognizably monastic. Antony had been a monk for some forty-five years and around 313 had moved to his interior mountain by the Red Sea. Around 320 Pachomius founded the first community of his *koinonia* at Tabennisi in Upper Egypt. In 328 Athanasius became bishop of Alexandria, and by 330 was visiting the monks in the Thebaid. Thus, by 330 the alliance between the episcopate of Alexandria and the monks of Egypt was already being formed. It is an alliance that continues to this day: the present leader of the Coptic Orthodox Church, His Holiness Pope Shenouda III, is a monk and takes

his name from one of the most famous monks of Egypt, St. Shenute the Great (385–465). The pope spends part of each week in Cairo and Alexandria and part at the patriarchal compound at the Monastery of St. Pshoi, one of four active monasteries in the Wadi al-Natrun.

By the end of the fourth century, a mere fifty years after Amoun and Macarius had gone out into the desert, Nitria may have had as many as 3,000–5,000 monks. More important than numbers, the monks bequeathed a spiritual tradition that was to profoundly affect all of Christendom. The roots of this tradition can best be seen in the *Sayings of the Desert Fathers*, which probably had its origins in Scetis. Originally written in Greek, and translated into Latin, Coptic, and Syriac, then Armenian, Georgian, Arabic, Ethiopic, and Old Slavonic, the *Sayings* deeply influenced the spiritual traditions of the eastern and western Churches. As auspicious as were the beginnings of monastic life in Nitria, Kellia, and Scetis, the first full flowering of monasticism lasted only a hundred years before two disasters shook the three settlements.

The very vitality of the monastic tradition created internal tensions that by the end of the fourth century were fracturing monasticism and making it a house divided against itself. The internal destruction came because of the theological conflicts over Anthropomorphism and Origenism at the very end of the fourth century, disputes over theology and the nature of God. Nitria, Kellia, and Scetis, though damaged, would have survived such turmoil, but just a few years later, in 407 or 408, the Mazices, Berber invaders from the Western Desert, devastated Scetis. Three years later, in 410, the year of the sack of Rome, invaders struck again. In one of the more poignant exclamations in Church history, one monk reportedly cried out, "The world has lost Rome; the monks Scetis." A third sack occurred in 434. Each time the monks returned and rebuilt, at least to some extent, and, beginning in the fifth century, they started to add fortifications, but Scetis lost many of its most eminent monks: Moses the Black and seven companions were slain; John the Little and

Bishoi, founders of two monasteries in Scetis, fled and died soon in exile. Destruction and rebuilding became a motif of the monasteries through their later history.

Monastic Life

The first community at most monastic sites (excepting the Pachomian communities) was probably a *laura* (or *lavra*), consisting of scattered cells or *monastêria*, "small, low houses," where the monks lived separately, as the monks did at Kellia and other fourth-century monastic communities. These monks had been attracted by the holiness of an *abba* or "father," and had come to live with him as his disciples. This was the origin of many a later monastery. The early "monastery" also most likely included a well and a church, with a refectory being added later. These communities were undoubtedly semi-anchoritic, like Kellia and Scetis, in their early years, rather than cenobitic like the communities of Pachomius and Shenute. The monks lived in individual cells, separate from each other, and gathered together on Saturday and Sunday for a communal meal and worship. The organization was minimal, with an *abba* as leader, and without a formal rule. However, a centripetal tendency, primarily for reasons of safety and security, gradually brought the monks together in more of a cenobitic community behind great walls, as one sees today in the monasteries of Egypt.

This process usually had two stages: first, a keep (*qasr*) or tower of refuge was built, in which the monks could hide from marauders. The monasteries of Scetis (Wadi al-Natrun) were devastated many times in the fifth century, and it appears that keeps were built there in the mid-fifth century. Later, the central monastic area was fortified with a high wall; this took place in the ninth century at the monasteries of Scetis. Even with the enclosing of the monastery, however, it is probable that some monks continued their semi-anchoritic lives outside the walls in smaller compounds (Coptic: *ma ñshôpe*; Arabic *manshubiya*); these dwellings, or at least their sandy shadows, can still be seen at the

deserted Monastery of St. John the Little in the Wadi al-Natrun, and at many other sites. By the fourteenth century, monks throughout Egypt seem to have abandoned these buildings and moved inside central enclosures.

The monastic cell is the most basic architectural element of monasticism. Each of the modern monasteries of the Wadi al-Natrun has large new buildings for the monks' cells, but they have been built with a very clear eye on the past and a solid understanding of the contemplative life. Fr. Matta reports in *Coptic Monasticism and the Monastery of St. Macarius* that:

> In the design of the cell we have kept in mind the principle of seclusion, which is a characteristic of Coptic monasticism. It is arranged in such a way that the monk may stay alone for many days with no need at all to leave the cell. It is provided with sufficient windows to admit fresh air, sunshine, and light, has a bathroom connected with a main sewage system, a separate kitchen, a small room—"a closet"—with a wooden floor on which a monk may sleep with no danger to his health, no matter how thin he may be, and a room for study and keeping vigil with a desk and wall cupboards. In order to ensure the necessary quietness, care was taken that each cell should be completely separate from the neighbouring cells, having a spacious veranda on one side and a staircase leading to the upper floors on the other. The roofs have been made thick, giving almost double the usual amount of sound insulation, and most of the furniture used is fixed to avoid noise.

The monk's cell is designed for prayer; it follows a very ancient monastic pattern of allowing for two rooms (the addition of a kitchen does modify the ancient pattern), an anteroom for work, and a back room for

sleep and prayer. Much has changed in Coptic monasticism in 1,500 years, but the most basic element has not: the cell is the center of monastic life, and it, like the life, was and is designed for quiet and prayer. The monks' lives are organized around prayer and they pray about every three hours, either together or individually. The first office (appointed time for prayer) takes place at about six or seven, the First Hour, which varies during the year, depending upon when the sun rises. This is the office of Resurrection. The monks say the opening prayers and then the prayers and Psalms and Gospel passage for the morning, then they conclude with prayer. Next they pray at the Third Hour, about nine, the office that commemorates Christ's betrayal and also the gifts of the Holy Spirit. In the same way, the Sixth Hour marks Christ's crucifixion and the Ninth Hour his death. The Eleventh Hour is also called the Sunset Prayer, the time when Jesus was taken from the cross and prepared for burial. At this office the monks say the Kyrie forty-one times, thirty-nine for the lashes Christ suffered, once for the crown of thorns, and once for the spear in his side. Then comes the Prayer of the Veil, which is for monks only and focuses on judgment. Finally, they pray together the midnight prayers, which remember Jesus in the garden of Gethsemane.

For the ancient monks, the desert was a cell, so they lived in a cell within a cell. As mentioned earlier, monasticism in the Wadi al-Natrun was originally anchoritic or semi-anchoritic, where each monk lived alone in a cell, often within proximity of other monks in their cells, not in large *cenobia* or monasteries as later and as today. Today, a monk may move to a hermitage after living a long time in the *cenobium*. It is important to remember that the hermit, though alone, is still very much part of the monastic and ecclesiastic community. Monasteries, like houses, have individual and communal space. The cell is the individual center of a Coptic monastery, while the church (or churches) provides the communal center—and, always located close to the church, is the ancient keep (*qasr*), or tower, the monastery's self-contained fortress in times of

invasion. The church and the keep offer a striking juxtaposition. Both provide sanctuary: the church, a communal sanctuary of spiritual calm, prayer, and worship; the keep, sanctuary for the community in time of danger. The keep is a powerful reminder of the precariousness of monasticism—and Christianity—in Egypt.

Before you enter a church in Egypt you first take off your shoes, because you are about to step on holy ground. When you enter a monastic church, you smell the incense as you feel the coolness of the air and as your eyes adjust to the darkened interior. What is most striking about monastery churches is how palpable everything is: icons are to be touched because they embody the holy (the worshiper touches the icon, then kisses his or her fingers), as do reliquaries (each church prominently contains relics) and even the door screening off the sanctuary where the priests celebrate the Holy Eucharist. In one church, a newly discovered ancient wall painting has been placed inside where, shielded by glass, the faithful can still "touch" it. In the Church of the Virgin at the Monastery of the Syrians, a team from France and Holland, while cleaning and restoring the painting of the Ascension above the entrance to St. Bishoi's hermitage in 1991, discovered beneath it a brilliantly colored ninth-century wall painting of the Annunciation. This painting was somehow taken down and placed in a corner of the church near the apse, where it is protected by a wood grille; inside you can see slips of paper dropped in by the faithful with petitions for the Mother of God.

Coptic spirituality is not abstract; just as it is physical, it is also intensely symbolic. "Symbol" is not an adequate term, however. Perhaps "lived symbol" can approach the reality. For example, the monks believe that their monasteries are in the shape of an ark, representing Noah's ark. A poster available in the monastery gift shops shows the ark of the Church riding out the tempest. The animals of Noah's ark have been replaced by photographs of all the Coptic bish-

ops. They are, then, both metaphorically and eschatalogically, riding out the storms of a drowning world to salvation. Each monastery is steeped in myth ("myth" not in the modern sense of a falsehood but with the sense of embodying an abiding religious truth), with stories of its eponymous founder or founders: once, when Christ was passing the cell of St. Bishoi, the saint washed his master's feet. Another time, St. Bishoi carried an old man whom the monks found alongside the road and whom the other monks passed by; the old man was Christ. The Mother of God visited St. John Kame. A poet may have greater insight into these stories than the historian. As Kathleen Norris put it: "To appreciate the relevance of [hagiographical stories] for our own time, we need to ask not whether or not the saint existed but why it might have been necessary to invent her; we need not get hung up on determining to what extent her story has been embellished by hagiographers but rather ask why the stories were so popular in the early church, and also what we have lost in dismissing them." As Jesus would say to those visiting these monasteries today: "Let those with ears listen and let those with eyes see."

Bibliography

Agpia 1997; du Bourguet 1991a; Chitty 1966; Daly 1990; Descœudres 1989; *Dossiers histoire et archéologie* 133, 1988; Evelyn-White 1932; Evelyn-White 1933; Evetts (ed.) 1895; Frend 1972; Garitte 1943; Grossmann 1991c; Guillaumont 1977; Hardy 1952; Jerome 1841-64; Judge 1977; *Les Kellia* 1989; Leipoldt 1903; Meinardus 1977; Meinardus 1992; al-Meskeen 1984; Meyer 1964; Norris 1996; Patrick 1996; Pearson 1986; Rubenson 1995; Russell 1980; Russell 2000; Socrates 1978; Trigg 1998; Veilleux 1980-82; Veilleux 1986; Vivian 1998; Vivian 1999; Vivian and Athanassakis 2002; de Vogüé 1991; Ward 1984; Watson 1996.

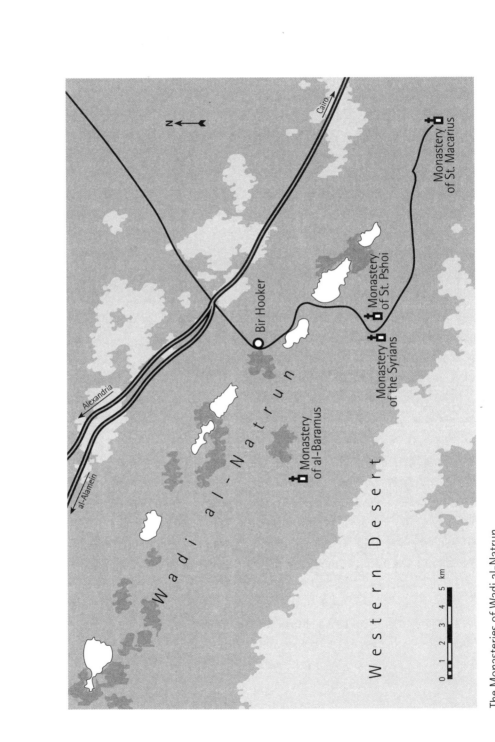

The Monasteries of Wadi al-Natrun

The Monasteries
of Wadi al-Natrun

The most important monastic center in Egypt is undoubtedly that located in Wadi al-Natrun, "the valley of natron," a desert depression about 50 kilometers long. It runs in a northwesterly direction and lies in the Libyan desert about 90 kilometers northwest of Cairo. This district has been known by many names which derive from a number of languages: Scetis, Scythis, al-Isqit, Shiet, Shihat, and Wadi Habib. The monasteries of Wadi al-Natrun developed from hermitic settlements, which began when St. Macarius (ca. 300–ca. 390)—known as St. Macarius the Egyptian or St. Macarius the Great—withdrew into the valley around 330. A community comprising many monks formed around him. Several literary sources provide details about the life of the monks in Scetis during the late fourth and the early fifth centuries. Monasticism developed a form of semi-anchoritism there. Hermits lived in cells or caves comprising two or more rooms, one of which functioned as an *oratory*. A new monk apprenticed himself to an experienced father and became his disciple. Monks earned their living by plying crafts, especially basketry and ropemaking. On Saturday and Sunday the monks gathered in the church to celebrate Mass and sometimes to take a Sunday meal in common.

By the end of the fourth century four monastic settlements existed in Wadi al-Natrun. Each of them had a kind of council, one of the responsibilities of which was, apparently, communication with the "world." The council was also responsible for keeping the general discipline in the monastery. Guesthouses were available for visitors, who started to come

towards the end of the fourth century to study monastic life. These four settlements were the origin of the four monasteries of Old Baramus, of St. Macarius (Anba Maqar), of St. Pshoi (Anba Bishoi) and of St. John the Little. The monasteries of St. Pshoi and of St. Macarius still exist. Remains of the Monastery of St. John the Little have recently been discovered. The nomads of the Libyan desert sacked and destroyed the monasteries of Wadi al-Natrun in 407, 434, and 444. Because of further attacks by the Berbers the monks erected towers to live in, and in the ninth century, apparently following another attack in about 817, they erected walls to fortify their monasteries. In the centuries to come the monks began to leave their scattered cells in the Wadi al-Natrun to live within fortified monasteries. By the fourteenth century monastic life appeared to be more cenobitic as the monks gathered within the enclosure walls for protection.

A theological dispute between Julian, Bishop of Halicarnassus (d. 518) and Severus, Bishop of Antioch (ca. 465–583) on the corruptibility or incorruptibility of Christ before the Resurrection divided the Coptic Church into two factions. This controversy affected the monastic settlements or *lauras* of Wadi al-Natrun, and towards the end of the sixth century the followers of Severus founded another four monasteries as "counterparts." The present monastery of al-Baramus—known as the Monastery of the Virgin of Baramus—is the counterpart monastery of the Old Baramus or the *laura* of Baramus. The Monastery of the Virgin of Anba Bishoi—known later as the Monastery of the Syrians—is the counterpart monastery of the old monastic settlements or *laura* of Bishoi. The counterpart monastery of the *laura* of John the Little survived until the fourteenth century or perhaps even longer. No monuments have been found to locate the counterpart monastery of the old monastic settlement or the *laura* of St. Macarius. Around 840 the Monastery of John Kame was established, and it survived until the fifteenth century. Thereafter the monks transferred the relics of their saint to the Monastery of the Syrians.

During the first centuries of monasticism in Egypt tens of thousands of monks inhabited monastic settlements throughout the country. According to John of Petra, who probably had to flee from Scetis during the fourth sack (ca. 570), 3,500 monks lived there around 550. Because of the poll tax, which was imposed on the monks from 705 onwards, monasticism began to decline. The Coptic historian Mauhub ibn Mansur ibn Mufarrig states that there were only 712 monks at Wadi Habib (Wadi al-Natrun) in 1088, divided among seven monasteries: 400 monks in the Monastery of St. Macarius, 156 in the Monastery of John the Little, 60 in the Monastery of the Syrians, 40 in the Monastery of Anba Bishoi, 25 in the Monastery of John Kame, 20 in the Monastery of al-Baramus, and two in the Cave of Moses. The drastic decline of Scetis has been documented by the Arabic historian al-Maqrizi (d. 1441). Only a few monks lived in the great Monastery of St. Macarius at that time. A number of monasteries fell into ruins and other were abandoned, such as the Monastery of John the Little, which was empty of its monks in 1493. In 1712 there were only four monks each in the monasteries of Anba Bishoi and Anba Maqar. Twelve monks lived in the Monastery of the Syrians and another dozen in the Monastery of al-Baramus.

The monasteries of Wadi al-Natrun played a crucial role in the history of the Coptic Church. Ethiopian, Syrian, Franciscan, and Armenian monks enriched the cultural life of the area in medieval times, endowing it with a multiethnic character. Beginning in the eighth century most of the Coptic patriarchs and many bishops were chosen from among its monks. The monasteries of Wadi al-Natrun provide indispensible data for the study of the Coptic heritage, and especially for Coptic literature, art, and architecture.

Bibliography

Cody 1991a; Evelyn-White 1926; idem 1932; idem 1933; Grossmann 1997; Samuel 1998; Samuel and Grossmann 1999.

The Monastery of al-Baramus

The Monastery of al-Baramus is the northernmost of the monasteries in Wadi al-Natrun. (see plate 1.1) There is more than one tradition concerning the name and the foundation of al-Baramus. The most famous is associated with Maximus and Domitius. The Arabic name Baramus derives from the Coptic *Pa-Romeos*, "that of the Romans." Coptic texts and tradition introduces them as Roman saints and children of the Roman emperor Valentinian—presumably Valentinian I (364–375). They went to Scetis in the days of St. Macarius, lived in a cell and died there. Macarius ordered the building of a church in their memory. The church was named the "Cell of the Romans" by Paphnutius, Macarius's successor. It became the center of the monastic settlement there, and there is no doubt that the present Monastery of al-Baramus is one of the oldest establishments at Wadi al-Natrun.

The current monastery of al-Baramus is significant for many reasons. It was founded on a site in front of the Old Baramus monastery incorrectly known as "the monastery of Moses the Black," where the oldest monastic community of Wadi al-Natrun stood. The monastery preserves its earlier character and possesses the oldest church that still exists in Wadi al-Natrun. This Church of the Virgin of Baramus is decorated with huge partially preserved episodes of a Christological cycle, an exceptional case of monastic wall paintings in Egypt in the medieval period. The keep, or *qasr*, of the monastery is the oldest extant tower at Wadi al-Natrun.

The present monastery is dedicated to the Virgin of Baramus, and was probably founded in the late sixth century as a counterpart of the Old Baramus monastery. The grounds are surrounded by a huge enclosure wall and one enters through a small door on the wall's eastern side. The Church of the Holy Virgin Mary, situated near the western side of the wall, is the main church of the monastery. It originates from the last decade of the sixth or the beginning of the seventh century. The church

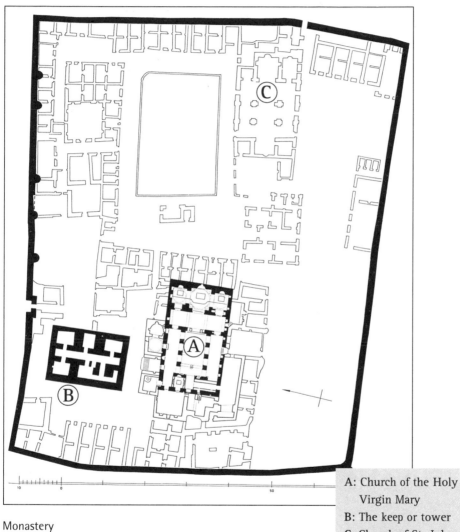

Monastery
of al-Baramus

A: Church of the Holy
 Virgin Mary
B: The keep or tower
C: Church of St. John
 the Baptist

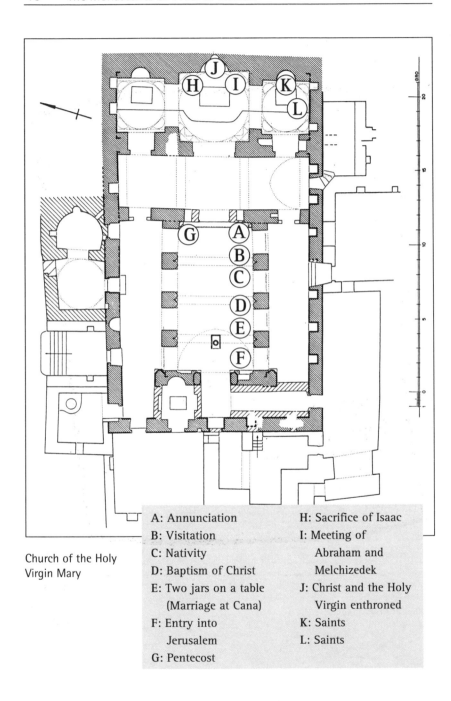

Church of the Holy
Virgin Mary

A: Annunciation
B: Visitation
C: Nativity
D: Baptism of Christ
E: Two jars on a table
 (Marriage at Cana)
F: Entry into
 Jerusalem
G: Pentecost

H: Sacrifice of Isaac
I: Meeting of
 Abraham and
 Melchizedek
J: Christ and the Holy
 Virgin enthroned
K: Saints
L: Saints

is thus the oldest preserved in Wadi al-Natrun. It is a basilica with a *khurus*, a room preceding the sanctuary, which was added to the church, presumably in the eighth or the ninth century. The central sanctuary was rebuilt in the thirteenth century. A dome on squinches was added during the pontificate of Patriarch Gabriel III (1269–1271). In a later period the columns of the church were replaced by oblong pillars. At the west end of the south aisle there is a beautiful large capital ornamented in stucco, which is a rare example of its type in Egypt. Against the north wall of the *khurus* there is a feretory, containing the relics of the saints Maximus, Domitius, and Moses the Black.

Between 1986 and 1989 three superimposed paintings were discovered in the church. The oldest, dating to about 1200, is the most significant. The drawings of the artist dubbed "first-Master" show originality and individuality. He decorated the central nave of the church with scenes of the Great Feasts; on the southern wall, from east to west, are the Annunciation, (see plate 1.2) the Visitation, (see plate 1.3) the Nativity, the Baptism of Christ, two jars on a table, and the Entry into Jerusalem. On the northern wall, he painted the feast of Pentecost. The upper left part of the eastern wall of the central sanctuary is decorated with a huge scene of the Sacrifice of Isaac, of which only some fragments remain. The right upper part shows a fairly complete scene of the Meeting of Ibrahim and Melchizedek. Both scenes are also the work of "first-Master." Melchizedek stands before an altar of masonry giving a spoon from the chalice to Abraham. The representation of Abraham as if he were receiving Holy Communion is not unknown in Coptic art, but the appearance of the spoon in this context is unique. (see plate 1.4) The apse is decorated with the usual two-zoned composition; above is Christ enthroned and below is the Holy Virgin Mary between the two angels. The decoration of the apse seems to be the work of a second master. (see plate 1.5) The paintings of the southern sanctuary are attributed to "first-Master." Its eastern wall shows a row of six saints: from left to right, St. Paul the Hermit, St. Antony, St. Macarius, a St. John, St. Maximus, and St. Domitius. Eight

saints are represented on the southern wall: from left to right, three anonymi, St. Pachomius, Moses the Black (?), St. Barsum the Syrian, (see plate 1.6) St. Paphnutius (?), and St. Onnophrius. The work of restoring the wall paintings is not yet completed, and more scenes may be uncovered. However, the drawings of "first-Master" are of high quality and some of them belong among the masterpieces of medieval Coptic art.

To the north of the Church of the Virgin lies the keep, called by the monks al-Qasr. It is the oldest keep in Wadi al-Natrun and probably dates from the ninth century. The tower, entered at the first floor by way of a drawbridge, features a corridor with rooms on either side. On the second floor there is a church dedicated to St. Michael. The keep was constructed over a well, which provided the monks with water in the case of a long siege.

There are two refectories in the monastery, but only the first is accessible to visitors. It is a rectangular hall to the south of the Church of the Virgin Mary, divided into three domed bays by two pointed arches. A brick table occupies the whole length of the hall. The older refectory is now used as a storeroom. It abuts the west wall of the monastery and consists of a square room with a central oblong pillar and four domed bays. The monks sat on benches that formed circles, an arrangement that continued until the end of the Fatimid Period when a single long table replaced them.

A new church, dedicated to St. John the Baptist, was built at the end of the nineteenth century. It contains little of interest apart from its epiphany tank, which is the only one in Wadi al-Natrun.

Bibliography

Cody 1991; Descœudres 1998, p. 71; Gabra 1997; Grossmann 1982, p. 122 f.; idem 1991; Grossmann and Severin 1997; van Loon 1999, pp. 61–74; Moorsel 1991; idem 1992; idem 1998; Urbaniak-Walczak 1992, p. 171 f.

The Monastery of St. Pshoi

The Monastery of St. Pshoi, (see plate 2.1) one of the four most ancient monasteries of Wadi al-Natrun, bears the name of its patron, who with his spiritual friend, John the Little, embraced the monastic life and settled in Scetis in the late fourth century. According to the *Life of St. Pshoi*, which is attibuted to John the Little, Pshoi established himself in a cave which lay two miles north of the place of John the Little. This is indeed the actual distance between the present Monastery of St. Pshoi and the recently discovered ruins of the Monastery of St. John the Little. When tribes living in the Libyan desert attacked Scetis in 407, Pshoi took refuge in the mountain of Antinoë (Antinopolis), where he died. His body was transferred to his monastery at Wadi al-Natrun at some point before the end of the eleventh century.

The Monastery of St. Pshoi is one of the original monasteries of Scetis. Its counterpart-monastery is that of the Syrians, which was built in the sixth century by the followers of Severus or the Theodosian monks. The Monastery of St. Pshoi is the second residence of His Holiness Pope Shenouda III, where he usually spends two or three days a week. (see plate 2.2) For this reason it is the destination of thousands of the Copts who visit Wadi al-Natrun. The monastery's gateway, which possesses an inner gatehouse and a large, carefully built tower, is the best-preserved in Wadi al-Natrun.

The monastery is nearly oblong in shape. A gateway near the western end of the north wall provides access. The gateway with its gatehouse is the most complete and elaborate of its kind in Wadi al-Natrun. The southern half of the monastery is occupied by the church and cells of the monks, as well as a modern patriarchal residence. The greater part of the gardens and the keep are in the northern half.

The most interesting building in the monastery is the tower. It dates from the thirteenth century and is a few years older than the keep of the Monastery of St. Macarius. One enters it at first-floor level by a draw-

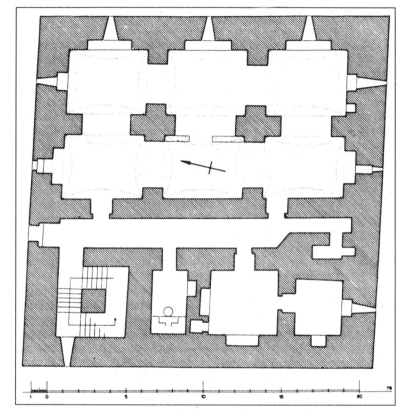

The keep of
the Monastery
of St. Pshoi

bridge (see plate 2.3) that rests on the roof of the gatehouse. On the first floor there is a long corridor, with the stairs and bathrooms on its western side, and two rows of rooms on the east side. These rooms were originally intended to be part of a church which was, however, never completed. On the second floor is the Church of St. Michael. The monastery's main church is dedicated to St. Pshoi. It has been restored and extended several times. It had been suggested that the most ancient parts of the church do not predate the fifth attack on the monasteries of Wadi al-Natrun, which occurred between 830 and 848. The church is older than this. It once had a three-aisled nave with a western return aisle, a *khurus*, and a tripartite sanctuary. The feretory for the relics of the Sts. Pshoi

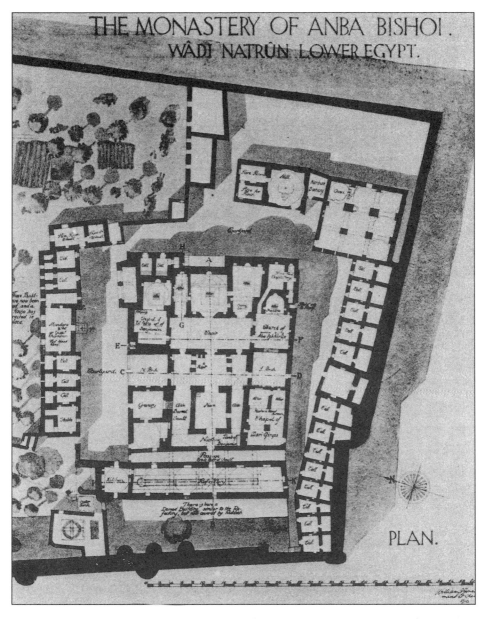

Church of St. Pshoi
(after Evelyn-White 1933, pl. 37)

and Paul of Tamweh stands at the northeastern corner of the *khurus*; that for the body of Patriarch Benjamin II (1327–1339), who undertook the restoration of the monastery, lies in the southwestern corner of the nave. It is noteworthy that remains of wall paintings were recently discovered in the so-called "Chapel of Benjamin." They depict three of the Twenty-four Elders of the Apocalypse, probably St. Stephen and other saints, and the Three Hebrews in the Fiery Furnace. They probably date from the second half of the twelfth century. The restoration of the wall paintings in the Monastery of St. Pshoi is not yet complete. The church, or rather a *parekklesion* of St. Iskhyrun (Abu Iskhirun), was apparently added in the eleventh century. It is reached from the south side of the *khurus* of the Church of St. Pshoi. The baptistery is located to the north of the sanctuary of the Church of St. Iskhyrun.

The monastery possesses three refectories. The latest lies parallel to the west end of the main church, from which it is separated by a vaulted corridor. It consists of a long room that is divided into five domed bays by five transverse arches. A masonry table occupies the entire length of the hall. The two other refectories are of an older type. The smaller one lies southwest of the main church. At an undetermined date it was transformed into the present chapel of Mari Girgis. It comprises a square room with a central pillar from which spring four arches. In the southeastern corner of the monastery stands the third refectory, which is now used as a storeroom. A bakery and a millhouse are in the northeastern corner of the monastery. The latter is the most complete example of its kind in Wadi al-Natrun. **(see plate 2.4)**

The patriarchs Gabriel VIII (1586–1601) and Macarius III (1944–1945) both came from the Monastery of St. Pshoi.

Bibliography

Cody 1991b; Coquin 1991; Grossmann 1982, p. 213–215; idem 1991a; Immerzeel 1992; van Loon 1999, pp. 75–82.

The Monastery of the Syrians

The relationship that existed between the Coptic Church and the Church of Antioch was influenced by two factors. Firstly, the traditional ties between the two churches were reinforced after both became isolated from the rest of the Christian world following the Arab occupation. Secondly, the existence of Syrian monks in the Monastery of the Syrians (Dayr al-Surian) (see plate 3.1) in the heart of the most important Coptic monastic center at Wadi al-Natrun.

The monastery was erected as a result of a sixth century schism caused by Theodosian monks. These followers of the doctrines of Severus of Antioch left the Monastery of St. Pshoi to found their own monastery nearby. Around 710 Syrian merchants purchased the

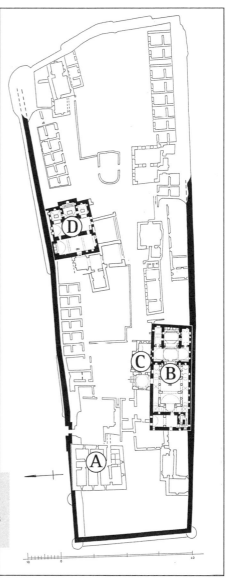

A: The keep
B: Church of the Holy Virgin Mary
C: Church of the Forty-nine Martyrs
D: Church of the Lady Mary

Monastery of the Syrians

monastery for 12,000 dinars. A certain Marutha, from Takrit in eastern Syria, converted it for the use of compatriot monks. The Monastery of the Syrians was sacked by nomads in about 817 and was restored around 850. According to some Syriac manuscripts of that time it was called "the Monastery of the Mother of God of the Syrians." The tower and the enclosure wall which still surrounds the monastery's buildings date from the ninth century.

The Monastery of the Syrians provides a great opportunity to study the development of Coptic wall painting. Between 1991 and 1999 several segments of wall paintings layered on top of each other were uncovered in the Church of the Holy Virgin Mary and the Chapel of the Forty-nine Martyrs. They range in date from the seventh to the thirteenth century. Of particular significance is a unique scene of the Annunciation. New Coptic texts and Syriac inscriptions continue to come to light as a result of recent conservation campaigns. The *khurus* of this church is the oldest of its kind in Egypt. From the library of the Monastery of the Syrians have come Syriac manuscripts which, dating from the fifth, sixth, and seventh centuries, are the oldest known. It is to be noted that the majority of the five hundred and eighty-one Syriac manuscripts described in the British Museum catalogue were associated with the Monastery of the Syrians. The monastery's library possessed hundreds of Arabic volumes, which are invaluable sources for the study of the Christian Arabic literature of the Copts, and a number of Syriac manuscripts.

In the first half of the tenth century the monastery flourished under the famous hegomenos (a title given to priests and monks to emphasize their leading role), Moses of Nisibis (ca. 907–943). It was he who constructed the doors of the sanctuary of the Church of the Holy Virgin Mary and perhaps other decorative elements as well. Moses of Nisibis was probably also responsible for the building of the Chapel of the Forty-nine Martyrs. In 1088 sixty monks inhabitated the monastery, making it one of the largest of the seven monastic communities in Wadi al-Natrun. By 1155/6 (or 1165/6) it witnessed a period of troubles for ten

years when "no Syrian priest was present there." In 1412–1413 only a single monk was documented in the Monastery of the Syrians, apparently as a result of the Black Death, which had scourged Egypt in 1348–1349, and the attacks of the Mongols in Syria in the beginning of the fourteenth century. In 1515–1516 forty-three monks lived there, but only eighteen of them were Syrian. The monastery remained predominantly in Syrian hands until the Coptic patriarchal synod installed a Coptic abbot in 1636–1637. Only two Coptic patriarchs came from the Monastery of the Syrians, Gabriel VII (1525–1568) and the present patriarch of the Coptic Church, Pope Shenouda III. Both patriarchs shared a common interest in restoring and repopulating abandoned monasteries.

The entrance to the monastery is located at the west end of the northern side of the enclosure wall. A court-

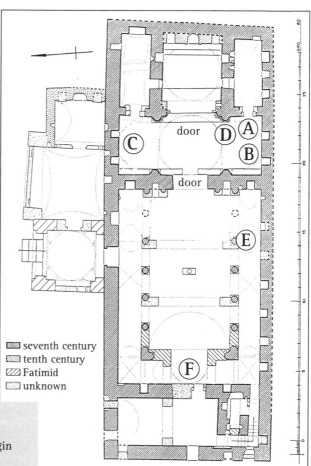

seventh century
tenth century
Fatimid
unknown

A: Annunciation
B: Nativity
C: Dormition of the Virgin
D: The Nursing Virgin
E: Three Patriarchs
F: Annunciation (plan after
 Innemée et al. 1998, p. 80)

Church of the Holy Virgin Mary

yard leads to the Church of the Holy Virgin Mary, which dates to approx- imately 645. It is of basilican type, which was originally covered by a wooden roof, and has a return aisle at its western end. To the east of the nave there is an original *khurus*. The sanctuary follows to the east of the *khurus*. A feature of the nave at its center is a small marble mandatum tank, which was used for the footwashing ceremony on Maundy and on the feast of St. Peter and Paul. To the west of the church there is a room which is accessible only from the nave. Its shape and position correspond with the narthex of Coptic churches, but its function is not clear. The staircase leading to the roof lies to the south of this room. According to tradition, St. Bishoi used it as a cell (this man is to be distinguished from the famous St. Pshoi, who lived in the fourth century, long before the establishment of this church).

The doors of the *khurus* and the sanctuary of the Church of the Holy Virgin Mary, which were constructed at the beginning of the tenth cen- tury, are most attractive. The door of the *khurus* has six rows of panels, while the sanctuary's door has seven. The wooden panels are inlaid with ivory. The decoration combines elaborate geometric design with figures of Christ and the Virgin Mary accompanied by saints. Syriac inscrip- tions enhance the design. The uppermost panels of the door of the *khu- rus* feature, from left to right, St. Peter, the Holy Virgin, Christ, and St. Mark. The uppermost row of the panels on the door of the sanctuary shows, from left to right, St. Dioscorus, St. Mark, the Holy Virgin Mary, Christ, St. Ignatius, and St. Severus. A Coptic sepulchral text of John Kame, a tenth-century saint, is inscribed on the western wall of the *khu- rus*' north side.

The decorative stucco-work in the sanctuary (see plate 3.2) of this church and in the Chapel of the Forty-nine Martyrs must be attributed to the beginning of the tenth century. The attempt to introduce this stuc- co style from Iran and Mesopotamia in the Tulunid Period echos the influence of Islamic art. The stucco ornaments are reminiscent of the ear- lier decoration of Samarra.

The paintings in the two semidomes of the *khurus* illustrate feast scenes appropriate to its dedication to the Holy Virgin Mary. They are attributed to approximately 1225. In the southern semidome, scenes of the Annunciation and the Nativity are depicted. To the left stands the Virgin of the Annunciation in front of a house with a small dome and an arched doorway, her hand raised to her chin in suprise. The angel Gabriel approaches her from the right, extending his right arm in greeting and carrying the herald's staff. The angel's greeting ("Hail, you who are full of grace! The Lord is with you!") is inscribed in Greek and repeated in Syriac. The scene features a wide variety of colors including red, purple, brown, and ochre against a blue and green background. The Nativity with the Adoration is depicted to the right of the Annunciation. The Virgin and Child monopolize the central area of the picture space with other elements of the scene distributed around them. The Holy Virgin reclines within a cave, resting her left hand upon her knee and her right on her breast. The child, wrapped in swaddling clothes, lies in a manger constructed of masonry. St. Joseph sits below the Virgin. The Magi are depicted as kings in the lower right corner, while the shepherds occupy the left corner. One of them sits playing a flute. Above a rocky hill, the herald angels crowd the blue sky, which is dotted with white stars. One of the Syriac inscriptions reads: "Glory be to God on high, and on earth peace, goodwill among men."

The northern semidome of the *khurus* is dedicated to Fall-Asleep or the Dormition of the Virgin. The Virgin's figure occupies the center of the scene. She lies on a draped bier with her hands crossed over her breast. Behind the bier Christ stands carrying the soul of the Virgin, represented as a baby swathed in white. The name of Christ is inscribed in Syriac over his head. Christ is flanked by two medallions, each enclosing an angel holding a *flabellum*. Sts. Peter and John bend over the head and feet of the Virgin, and on either side stand five apostles communicating with one another. In the upper register there is a *mandorla* carried by two angels. The hand of God, which is no longer pre-

served, was probably represented in the center of the *mandorla*. The blue sky is dotted with stars.

During successful restoration and conservation campaigns which began in 1991, a number of layers of plaster have been partially removed. Many mural paintings of different periods were discovered, and more wall paintings are expected to be found in the years to come. A scene of the Virgin suckling the infant Jesus (Maria Lactans or Galactotrophousa) was uncovered in the *khurus* on the half column to the right of the entrance of the sanctuary. (see plate 3.3) The enthroned Virgin wears a blue tunic and bluish-green *mophorion*, which is decorated with crosses. She holds the child on her lap with her right hand and presents her breast to him with her left. The mural painting, and especially the facial features of the Virgin, must have been painted by a skilled master. (see plate 3.4) The composition, which represents one of the most beautiful scenes of the Virgin and Child in Egypt, may date to the second half of the seventh century. On the southern wall of the nave a tableau showing the three patriarchs, Abraham, Isaac, and Jacob, was uncovered. (see plate 3.5) It depicts them enthroned in paradise with the souls of the blessed on their laps. The facial features and the hair of the patriarchs are schematically treated. They wear brown tunics and *pallia*; the one in the center wears a white *pallium*. Small naked figures symbolize the souls, held on the laps of the patriarchs, who are feeding fruits to the blessed. Behind the patriarchs there are naked figures picking fruits from the trees. This composition gives vivid expression to the prayers inscribed on Coptic gravestones from the eighth and ninth centuries: "May God repose his soul [that of the dead individual] in the bosom of Abraham, Isaac, and Jacob." The daily evening prayer of the Coptic Church contains the same prayer for the dead. This scene of the Three Patriarchs in Paradise, the earliest example in Egypt of such, can be attributed to the eleventh century.

The western semidome was decorated with a scene of the Ascension of Christ. This scene has been successfully removed and temporarily laid

on the church floor at the southeastern corner of the nave. An older scene of the Annunciation was revealed after the removal of the Ascension scene. The latter has been dated to about 1225. It came from the same workshop which executed the scenes of the semidomes of the *khurus*. The lower register shows the Virgin *orans* flanked by the twelve apostles, who are depicted conversing with one another or looking upwards towards Christ in the *mandorla* held by two angels in the upper register. In the upper register the enthroned Christ holds a book in his left hand and raises his right in blessing; to the right is the moon and to the left, the sun. All the elements of the scene are labelled in Syriac, while the names of Christ, the sun, and the moon are repeated in Coptic. (see plates 3.6 and plate 3.7)

The scene of the Annunciation, which has been recently discovered, is a unique masterpiece. (see plates 3.8 and 3.9) The angel Gabriel, bringer of good news, approaches the Holy Virgin from the left. He holds his cross-staff, and looks at the Virgin with his message written in Greek: "Hail, you full of grace! The Lord is with you!" The enthroned Holy Virgin is turned slightly towards the approaching angel, her right hand outwards and her left hand supporting her chin. In the middle of the scene is a censer with blue flame placed on a column. The imagery of the incense is exceptional in medieval Coptic wall painting. Four prophets surround the Virgin and Gabriel. Isaiah and Ezekiel are directly on either side with Ezekiel standing next to the angel. At the extreme left of the scene stands Moses; his counterpart to the right is Daniel. The names of the prophets are written in Greek. They carry the text of their prophecies, written in Boharic Coptic, on an opened scroll. Moses and Ezekiel wear red tunics and bluish pallia. Isaiah's tunic is beige and his pallium is red. Daniel on the extreme right wears Phrygian costume with a short tunic and peaked cap. The text of Moses reads: "I saw the bush while the fire was blazing in it, without being consumed." These words, which are adapted from Exodus 3:2, refer to the common title of the Virgin Theotokos as "the Burning Bush" in Orthodox hymns. The text of

Isaiah is the well-known prophecy: "Behold, a virgin shall conceive, and bear a son, and shall call his name Emmanuel" (Isaiah 7:14). The prophecy of Ezekiel reads: "Then said the Lord unto me: this gate shall be shut and no man shall enter in by it save the Lord, the God of Israel" (cf. Ezekiel 44:2). The last text is that of Daniel, which is a variant of Daniel 2:34: "I saw a stone cut out from the mountain without being touched by hands." In the background Nazareth is represented as a walled town with gates, a church, a tower, other buildings, and gardens. There is no doubt that this scene of the Annunciation is unique in Egypt. Its style differs completely from medieval Coptic painting. The dating of this painting is still a matter of controversy. A number of suggestions have been made by art historians: early eighth century, shortly after 900, the time of Moses of Nisibis during the first half of the tenth century, the late twelfth century, the 1170s–early 1180s, and the beginning of the thirteenth century. In support for dating the Annunciation scene to the first half of the tenth century the paleography (the study of the handwriting) of the Coptic and Greek labels of our scene can be cited. The letters are very similar to the forms used in many Coptic manuscripts of the ninth and tenth centuries. The occurrence of Coptic and the absence of Syriac inscriptions in the scene need not be explained by supposing a decline of the Syrian influence in the monastery. It may rather be understood as a diplomatic gesture from the Syriac community, which had the upper hand there, towards the Copts. It should be remembered that the Syrian monks were living in the heart of the most important Coptic monastic center. Almost all Coptic patriarchs of the time were chosen from among the monks of Wadi al-Natrun. One of them, Gabriel I (909–920), resided there. *The History of the Patriarchs* of the Coptic Church notes that: "He remained during the whole of his patriarchate in Wadi Habib (i.e. Wadi al-Natrun)." The same patriarch is mentioned in a dedicatory inscription on the door separating the *khurus* from the nave, recording the erection of the altar of the Church of the Thetokes by Moses of Nisibis under the patriarchs Mar Gabriel and Mar John (the latter was the patriarch of

Antioch). It is therefore very probable that this unique version of the Annunciation was painted when the Nibastert Monastery of the Syrians flourished under Moses of Nisibis, who was the abbot of the monastery at least as early as 914 CE.

The Monastery of the Syrians includes many other buildings. Among these, the Chapel of the Forty-nine Martyrs built in the tenth century deserves mention. It is situated on the north side of the Church of the Holy Virgin Mary. Some paintings have recently been discovered on the eastern wall of the sanctuary, where three niches are surrounded by rich decorative stucco-work. The central niche is decorated with a scene of the Holy Virgin holding Christ in front of her. The niche to the right is occupied by a standing figure with a Syriac inscription identifying him as "St. Mark [the] Evangelist." The figure of the saint depicted in the niche to the left is not identified by a text, but he might be the Patriarch Athanasius as a counterpart of St. Mark. The same composition is found in the old Church of St. Antony at the Red Sea. The decorative stucco-work of the frames of the niches is older than the painting and is attributable to the beginning of the tenth century.

Further to the east stands the Church of Lady Mary (*al-Sitt Maryam*). It was probably built before the eleventh century. The structure consists of a transverse room leading to a *khurus*, which is followed by a sanctuary built in the fourteenth or fifteenth century. The relics of St. John Kame are preserved in a feretory at this church. The cells of the monks and gardens occupy the eastern and southern parts of the monastery grounds. The keep lies next to the entrance of the monastery. It comprises a basement and three stories. The first floor has rooms with wall niches where books and archives were kept. The keep probably dates from the ninth century and belongs to a less developed type of tower, of which the oldest examples are to be found in Kellia.

The ongoing project to uncover, restore, and conserve more wall-paintings of different periods in the Monastery of the Syrians will considerably increase our knowledge about Christian art in Egypt. A new

museum is needed to display precious icons, manuscripts, and other treasures of the monastery, and especially to house the wall paintings which have been painstakingly removed, layer by layer, to reveal ever earlier masterpieces.

Bibliography

Brashear 1998, p. 107 f.; Brown 1981, p. 80; Cody 1991c; Descœudres 1998, p. 71; Grossmann 1991b; idem 1996, p. 52, fig. 10; Hunt 1985; idem 1995a; idem 1995b; Innemée 1998; idem 1999; Innemée et al. 1998; Krause 1975, p. 79; Leroy 1974; idem 1982; van Moorsel 1995.

The Monastery of St. Macarius

The Monastery of St. Macarius (Anba Maqar), named after its patron saint, Macarius the Great, who died in about 390, is the southernmost monastery in Wadi al-Natrun.

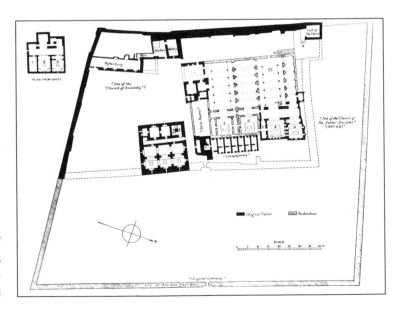

Monastery of
St. Macarius
(after Evelyn-
White 1933, pl. 5)

In some respects it is the most significant Coptic monastery. No other monastery supplied the Coptic Church with as many prelates as the Monastery of St. Macarius. Thirty patriarchs, or more than a quarter of the Coptic patriarchs, were chosen from among the monks of this monastery. Towards the middle of the sixth century, when the Byzantine rulers of Egypt did not allow Coptic patriarchs to reside in Alexandria, it became an occasional patriarchal residence. Many patriarchs consecrated the chrism (sacred oil) there. The culture on which nearly all Coptic ecclesiastical life was based radiated from the Monastery of St. Macarius for many centuries. A considerable amount of the Coptic literature written in the Bohairic dialect, which consists mainly of biblical, hagiographical, homiletic, and liturgical texts, was found in the Monastery of St. Macarius. The monastery had a large library, from which many manuscripts were removed to Europe.

Like the other monasteries of Wadi al-Natrun, the Monastery of St. Macarius was sacked three times by nomads during the fifth century. Shortly after the Arab occupation, Patriarch Benjamin I (626–665) consecrated a new church there where he issued his canons to the monks of the monastery. At that time, is it said, the head of St. Mark was recovered, which the Greeks had intended to smuggle to Byzantium. It was deposited in the monastery's sanctuary, which is named after him. According to Epiphanius of Jerusalem, who visited Wadi al-Natrun around 800, there were 1,000 cells protected by a fortress at the site of the monastery. Arab nomads pillaged the monastery in 866 and 869. It was therefore fortified in the pontificate of Patriarch Shenute I (858–880). In 1088 400 monks lived there. Beginning in the mid-fourteenth century the monastery witnessed a drastic decline due to the Black Death and the Mamluk persecution of the Copts, which included the confiscation of properties and the destruction of churches.

The monastery is entered from the western end of the northern wall. The churches of the monastery were restored several times throughout the centuries. The most interesting buildings are the old Church of St.

Macarius and the keep. (see plate 4.1) The former was dedicated in later times to St. John the Baptist and Patriarch Benjamin. The Church of St. Macarius, which lies in the monastery's northeast section, was originally larger than it is presently. It was consecrated by Patriarch Benjamin I between December 18, 645 and January 3, 646 (or 647). It has two sanctuaries; the southern is dedicated to St. Benjamin, and the northern to St. John the Baptist. The latter was known until the fourteenth century as that of St. Mark. The sanctuary is believed to have housed the head of St. Mark for a brief period. The wall paintings of both sanctuaries are attributable to the twelfth century. The entrance to the sanctuary of Benjamin features a lofty pointed arch over which the beautiful painting of the soffits features medallions. One of them shows Nicodemus and Joseph of Arimathea embalm-

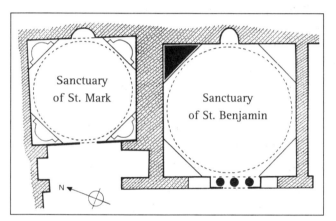

Sanctuaries of Sts. Mark (at present dedicated to St. John the Baptist) and Benjamin (after Leroy 1982, p. 12, fig. 1)

ing the body of Christ, another depicts them carrying the wrapped body. (see plate 4.2) According to Coptic tradition the apostles took the myrrh and aloes that had been brought by Joseph and Nicodemus for the burial of Christ, mixed them with the sacred oil, and thus made the first chrism. Many Coptic patriarchs consecrated the chrism in this sanctuary.

The sanctuary's western wall was originally decorated with a scene of the Ascension, with Christ between two angels flanked by a series of large standing figures representing the Apostles and the Evangelists, each depicted within an arcade, but most have now been destroyed. The figure of John the Baptist, (see plate 4.3) who wears a dark red tunic

and a yellow-brown cloak with white edging, is notable. With his left hand he holds a medallion containing a horned ram ("the Lamb"). Below, in the other direction, a faint scene of the two equestrian saints, Claudius and Mena, can be traced. The eastern, northern, and southern walls are occupied by a series of figures, sitting on jewelled thrones and

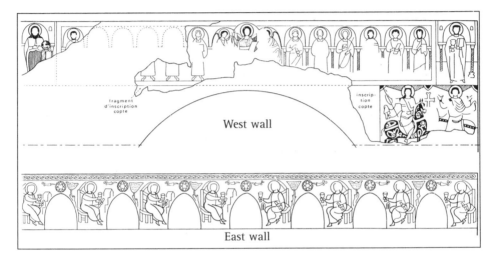

Sanctuary of St. Benjamin, west wall: Christ between two angels flanked by Apostles and Evangelists, John the Baptist, and equestrian saints; east wall: eight of the Twenty-four Elders (after Leroy 1982, diagram A)

holding small vessels. They represent the Twenty-four Elders of the Apocalypse. (see plate 4.4) In the soffit of the octagon there is a cherub depicted with a haloed human head, an oval body, and an egg-shaped tail. Its hands are outspread and its two wings have eyes in the edges. The painting features the four creatures of the Apocalypse: a bull, a lion, an eagle, and a human. (see plate 4.5) The northern sanctuary of St. Mark consists of a small front vestibule and the sanctuary itself, which is nearly square. On the eastern wall of the sanctuary, to the left,

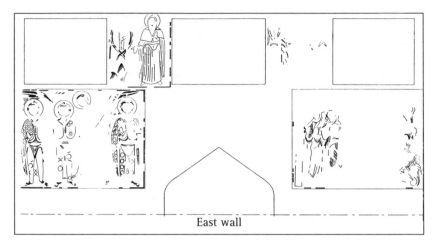

Sanctuary of St. Mark, east wall: The Three Hebrews and
the Entry into Jerusalem (after Leroy 1982, diagram D)

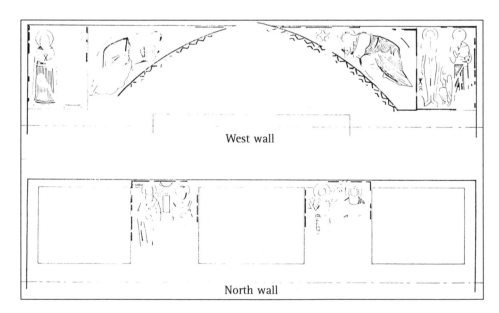

Sanctuary of St. Mark, west and north wall:
monastic saints (after Leroy 1982, diagram C)

a faint scene of the Three Hebrews still can be made out. To the right are the remains of a painting showing Christ's entry into Jerusalem. The north and west walls are decorated with several monastic saints; among them St. Onnophrius, St. Paul the Hermit, and St. Antony the Great can barely be distinguished. The octagon features several biblical themes:

1. Not identified.
2. In the spandrel, right: Jacob's dream, left: Christ and Nathanael. In the recess: the Resurrection.
3. The Sacrifice of Issac. In the arcature: Evangelists (see plate 4.6).
4. The Annunciation. In the recess: the Nativity.
5. Moses and Aaron. In the arcature: the *Deisis* (Virgin Mary and St. John) (see plate 4.7).
6. Annunciation to Zachariah.

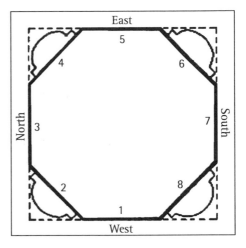

7. Left: The Purification of Isaiah. Right: Abraham and Melchizedek.
8. Job. In the recess: the Baptism of Christ (nearly destroyed).

The keep, which dates from the late thirteenth century, is considered to be among the most interesting keeps of Coptic monasteries. It contains a number of chapels and a church, which was used in times of danger and of siege. The keep has a basement and two stories. On the first floor the Church of the Holy Virgin Mary occupies the area in the eastern side of the long corridor. The woodwork screens of its sanctuaries were of fine workmanship from medieval times. A section of these beautiful wooden pieces has been transferred to the monastery's new museum. One of the rooms on the west of the corridors contains a winepress. In the second story there are three chapels to the east of the corridor. Most of their paintings were executed by the Ethiopian Tekla in 1517. The

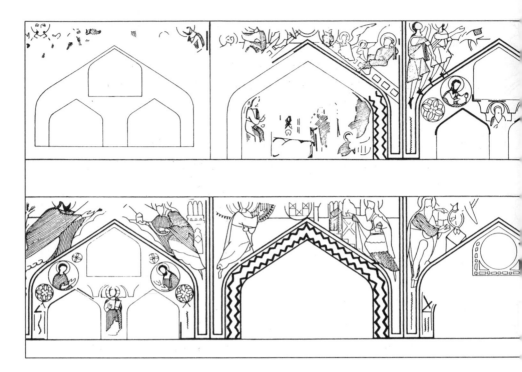

Sanctuary of St. Mark, octagon (after Leroy 1982, diagram B).

southern chapel is dedicated to the "Hermits." **(see plate 4.8)** On its northern wall, which retains some of its color, a number of saints are represented. From east to west they are: St. Samuel of Qalamun, St. John (Anba Yohannis), St. Onnophrius, St. Abraham, St. George, St. Apollo, St. Apip, St. Misael, and St. Pigimi. The middle chapel belongs to St. Antony. Its north wall features three great figures of monasticism: St. Antony, St. Paul the Hermit, and St. Pachomius. The northern chapel is that of St. Michael. Worthy of note are the murals on its southern wall showing a number of equestrian saints (east to west): St. Basilidis, St. Eusebius, St. Macarius, St. Justus, and St. Apoli son of St. Justus.

The monastery includes other buildings from different periods. The church of St. Iskhirun houses the bodies of St. John the Little and the

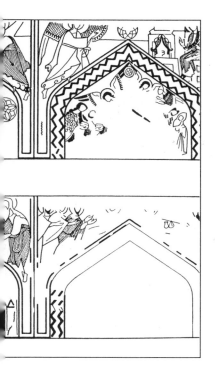

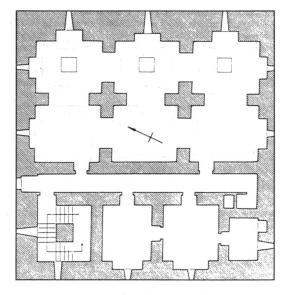

The keep (Grossman 1982)

three saints named Macarius: St. Macarius the Great, St. Macarius of Alexandria, and St. Macarius, bishop of Tikoou. The Church of the Forty-nine Elders is dedicated to the commemoration of the forty-nine monks who suffered martyrdom during the sack of 444. It was rebuilt by the notable Copt Ibrahim al-Gawhari (d. 1795). Since 1969 the monastery has been "modernized," and many renovations have considerably changed its appearance.

Bibliography

Coquin 1975; Grossmann 1982, pp. 213–215; Leroy 1971; idem. 1976, pp. 574–578; idem. 1982; van Loon 1999, pp.31–60; Matta al-Maskin 1991; Zanetti 1986.

The Monastery of the Archangel Gabriel in al-Faiyum

T he oasis of al-Faiyum is a large natural depression in the Western Desert which takes its water from the Nile. It lies about one hundred kilometers south of Cairo. Christianity was introduced to al-Faiyum as early as the second century. Nepos was the bishop of Arseinoe (al-Faiyum) in the middle of the third century. We are told that St. Antony (251–350) visited monks in the Faiyum. Many monasteries which once existed in al-Faiyum are known from several documents. One of the largest collections of Coptic manuscripts ever discovered comes from the ruins of the Monastery of the Archangel Michael near the present-day village of al-Hamuli in the west of al-Faiyum. This collection is preserved for the most part in the Pierpont Morgan Library in New York. Today the bishop of al-Faiyum resides at Dayr al-'Azab, which is situated about six kilometers south of the city of al-Faiyum. This monastery is famous because the body of the very popular new Coptic saint Anba Abraam, bishop of al-Faiyum and al-Giza from 1882 to 1914, is kept there. A small museum, dedicated to his body, preserves paintings and icons relating to the saint as well as a collection of letters signed by him. The portrait (see plate 5.1) which decorates his coffin is very reminiscent of the mummy portraits from antiquity known nowadays as the Faiyum portraits.

The earliest and most significant monastic center in the Faiyum is undoubtedly that of al-Naqlun. The ancient Monastery of Naqlun or Dayr al-Khashaba, known today as Dayr al-Malak Ghubrial (Monastery

of the Archangel Gabriel) is situated on a picturesque desert hillside between the Faiyum oasis and the Nile Valley, about sixteen kilometers southeast of the city of al-Faiyum. Until recently the only details known concerning its foundation was the Coptic legend of Aur, the illegitimate son of the queen's daughter and Abrashit the magician. Guided by the Archangel Gabriel, Aur went to the mountain of Naqlun and built a church there. In the 630s, Samuel of Qalamun established a community of one hundred and twenty monks and two hundred lay people at the site. The church historian Abu al-Makarim (early thirteenth century) referred to two churches, those of the archangel Michael and the archangel Gabriel, at Naqlun. By the fifteenth century, when the Arab historian al-Maqrizi (d. 1441) referred only to the Church of the Archangel Gabriel, the monastery was in decline, and when Wansleben visited the monastery in 1672 he found it, except for this same church, almost completely ruined. Beginning in 1986 excavations were carried

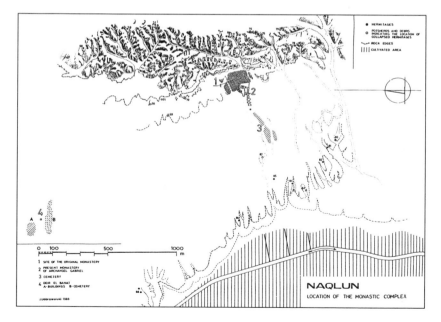

Monastery of Gabriel, al-Faiyum

out in the area of the Monastery of al-Naqlun which provided very interesting data about the history of monasticism at the site. The monastic complex spread over the plateau and into the valleys among the vast hilly area behind it at Naqlun. These valleys teem with rock-cut hermitages which were once inhabited by monks. The church and the other monastic buildings are on the plateau.

The archaeologists investigated the small valleys of Gabal al-Naqlun and found that almost all of them have hermitages cut into the rocky hills. About eighty of the eighty-nine hermitages which have been identified to date are scattered over an area of more than two square kilometers. In addition to the survey and a general archaeological investigation of the site, the excavators completely cleared five selected hermitage complexes at different locations at Naqlun. The men who cut the her-

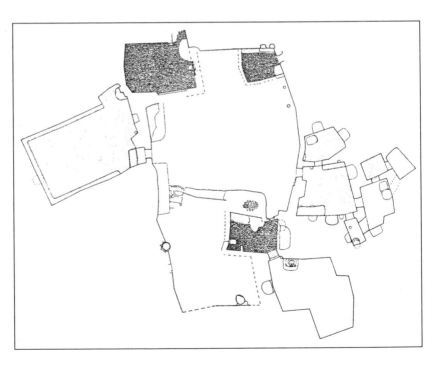

Hermitage no. 44

mitages into the rock and plastered their walls in antiquity were profes-
sionals. These dwellings show that hermits inhabited Naqlun as early as
the middle of the fifth century. As in Bawit, the owners sold particular
hermitages to other anchorites. One of the hermitages originates from the
second half of the fifth century; enlarged and renovated several times
over the centuries, it continued to be in use until the twelfth century.
Pilgrims still visited its oratory in the fourteenth century. Another her-
mitage features a central courtyard, three cells, and two kitchens. It
shows three phases of habitation dating to the late sixth or the early sev-
enth century, the middle of the seventh century, and the eighth century.
A single, presumably rich, monk occupied a most interesting large her-
mitage; he possessed glass vessels and plates imported from Cyprus and
North Africa. The hermitage consists of seven rooms, each accessible
from a central courtyard. (see plate 5.2) Apparently it had already been
abandoned by the second half of the fifth century. The pottery pots,
plates and oil lamps, textiles, objects of wood, leather and glass, as well
as many documents written in Greek, Coptic, and Arabic, and even one
in Latin, alongside biblical and liturgical texts discovered at Gabal al-
Naqlun, are of great value for the study of the history of monasticism
and the everyday life of the monks in different periods. No church was
found in the hills; it would seem that the hermits descended to the
plateau on Saturday and Sunday to celebrate Mass in the church there.

A number of limestone architectural sculptures—Corinthian capitals
and friezes—dating to the second half of the fifth century remain at
Naqlun. Some were reused in the present Church of the Archangel
Gabriel and presumably originate from an older church at the site.
Others were found in the recent excavations on the plateau where the
remains of a number of monastic buildings were discovered; two of
them are towers, one to the north and another to the south. The latter
was enlarged in the ninth, tenth, and eleventh centuries and became a
habitation complex. Some of its rooms served as the library, where
many parchment cards of Coptic biblical, liturgical, and magical texts,

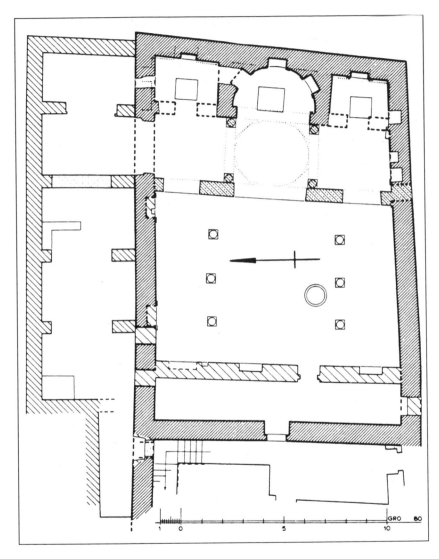

Church of the Archangel Gabriel

as well as Coptic and Arabic documents, were uncovered. The greater part of these texts can be assigned to the ninth and the tenth centuries. A fire, most probably during the early Mamluk Period, resulted in the abandonment of this part of the monastery. By the late thirteenth or the fourteenth century the monastery complex was confined to the area of the Church of the Archangel Gabriel. This church is now the most important Christian monument in al-Faiyum on account of the discovery and conservation in the 1990s of its very significant wall paintings. Probably built in the ninth century or even later, the church is constructed of burnt bricks and is designed as a basilica with three aisles. Its rectangular ground plan is slightly irregular. Two rows of three columns each separate the side aisles from the nave. Their limestone Corinthian capitals are not identical, and in fact they are much older than the construction of the church. The wall separating the present narthex from the nave was added at a later period. The eastern part of the church comprises the *khurus*, the main apse, and two lateral sanctuaries. The northern part features a long hall divided by several transverse arches. This hall, which was built at a later time against the northern wall of the church, was probably used as a refectory. Its eastern bay was turned into a baptistery.

In 1672 Johann Wansleben admired the Church of the Archangel Gabriel and described it as "very beautiful and painted in the inside with the passages of the holy Writ." However, superimposed layers of plaster covered the murals of the church. In the 1990s skillful professional restorers removed these plaster layers and conserved the beautiful scenes. A Coptic foundation text accompanying the paintings mentions Patriarch Zacharias (1004–1032). During the period of Zacharias's pontificate, the church was renovated and decorated with several mural compositions. On the southern part of the west wall of what is nowadays the narthex, the enthroned Virgin is shown between the Archangels Michael and Gabriel. Two doves appear behind the throne of the Virgin. The inclusion of the scene in this part of the

church and the occurrence of doves in it are unusual in Coptic art. To the right there are two equestrian saints who face each other. The inscription accompanying the southern figure identifies him as St. Pigoshe, (see plate 5.3) who does not appear elsewhere. An angel holding the martyr's wreath is depicted to the right of his halo. Below his horse a man points to a small building surmounted by a dome. Little is preserved of the other unidentified equestrian saint. There follows a representation of Christ in a *mandorla*, set within a cosmic cross. The northern wall of the actual narthex shows a haloed monk holding a staff surmounted by a cross. (see plate 5.4) He might be an abbot, probably Anba Shenute. The north wall of the nave is occupied by a representation of the Archangel Gabriel, the patron of the church, and three equestrian saints; the one in the centre is St. Mercurius. The paintings in the main apse are remarkable in that they differ in some details from the traditional Coptic decoration of this architectural feature. The remains of the lower part of the enthroned Christ in the *mandorla* are preserved in the concha of the apse. On either side of the large window with a stucco grille at the center of the apse, six Apostles are depicted. (see plates 5.5 and 5.6) They are represented standing and each holds a roll in his hand that bears a Coptic inscription indicating its contents. Thus, Peter holds a roll of letters and Andrew his sermons. The exception is John the Apostle and Evangelist, who holds a *codex*. St. Peter, whose bishop's garb and monk's cap differentiate him from the others, is identified by the associated text as the Archbishop Petros which shows that he represents both the Apostle and the martyr patriarch of Alexandria. The absence of the Holy Virgin Mary in the midst of the Apostles is unusual. Below there are three niches: The central niche contains the scene of the enthroned Virgin and Child, the northern niche features St. Mark the Evangelist, (see plate 5.7) and the southern niche holds an unidentified saint, presumably St. Athanasius. The same composition was found in the Monastery of St. Antony at the Red Sea.

The hermitages of Gabal al-Naqlun and the monastic buildings on the plateau represent a very rich source for the study of the history of Christianity in general and Coptic monasticism in the area of al-Faiyum in particular. The objects in various materials, the texts both biblical and liturgical, and the documents discovered there have considerably increased our knowledge of different aspects of the daily life of the anchorites and monks over almost one thousand years. The relatively well-dated eleventh century wall paintings of the church of the Archangel Gabriel are very important for the study of the development of Coptic art.

Bibliography

Abbot 1937; Alcock 1991; Coquin 1991a; Dobrowolski 1990; Depuydt 1993; Gabra 1997a; Godlewski, 1993; idem 1997; idem 1999; Godlewski et al. 1994; Grossmann 1991f; Hewison 1986; Timm II, pp. 762–766; idem IV, pp.1506–1525; Urbaniak-Walczak, 1993; Vansleb 1678, p.166; Wipszycka 1996, pp. 373–393.

The Monasteries
of the Eastern Desert

The monasteries of St. Antony and St. Paul lie southeast of Cairo, on the Red Sea. They can be reached from the capital either via Ain al-Sukhna and Za'farana down the coast, or by travelling up the Nile via al-Kuraimat. The distance by either route is about 300 kilometers.

The monasteries bear the names of two seminal figures of monasticism. The biography of St. Antony (251–356) that was written by Patriarch Athanasius (328–373) made the "Father of Monasticism" famous in Egypt and Europe as well. St. Paul of Thebes was known, according to Jerome, as the "first Hermit." He withdrew into the Eastern Desert in about 250 to settle at a spot near the Red Sea where his monastery stands today. Nearly 90 years later, St. Antony visited him there before the older saint's death. They were fed miraculously by the crow which brought bread for the sustenance of St. Paul; on the occasion of St. Antony's visit, the crow appeared with a whole loaf instead of the usual half. Unlike the sources on the life of St. Antony, those concerning St. Paul are problematic. Regardless of the actual relationship between the two saints, their monasteries are the most venerable in Egypt, and they were often depicted together in Coptic paintings. However, the Monastery of St. Paul is the smaller of the two and the sources relating to it, like the number of visitors who travel there and the number of scholars whose attention it has attracted, are considerably less numerous. The Monastery of St. Paul has simply stood in the shadow of St. Antony's monastery.

The Monastery of St. Antony

In the second half of the fourth century a monastic community seems to have grown up around the site where the saint lived. According to the historian and hagiographer Sulpicius Severus (c.360–c.420), there were two monasteries associated with the blessed Antony, as well as the place of the blessed Paul, by the beginning of the fifth century. From the *Life of St. John the Little*, we know that he had to leave Wadi al-Natrun for the Clysma area in 407, following the invasion of the nomads. According to the Ethiopian Synaxarion, St. John went to the Monastery of St. Antony. Apparently he spent the last two years of his life there and upon his death in 409 he was buried there.

It seems that towards the end of the eighth century the Monastery of St. Antony was controlled by the Melkites. Coptic monks from Wadi al-Natrun disguised themselves as Bedouins and entered the church to steal the relics of St. John. The church historian Abu al-Makarim, who lived in the twelfth or thirteenth century and has been known erroneously as Abu Saleh, reported that the Monastery of St. Antony was surrounded by a fortified wall with the monks' cells overlooking a garden and that it was unique among the monasteries inhabited by Egyptian monks.

Not a single scrap of papyrus or parchment has survived from the older Coptic manuscripts of the library, in contrast with what remains from the libraries of other monasteries. However, some of the colophons to manuscripts dating from the thirteenth to the eighteenth century are significant for the monastery's history and the literary activities of its monks. It is noteworthy that the library of St. Antony's monastery boasts the largest collection of Christian manuscripts in Egypt. The preparation of a comprehensive catalogue of its holdings, which amount to 804,000 pages comprising some 1,863 volumes, would certainly increase our knowledge about the monastery, the Coptic Church, and the Christian Arabic literature of the Copts.

The fame of St. Antony in Europe brought many travellers to his

monastery beginning in the Middle Ages and continuing to the present. In the absence of a serious archaeological study of the monastery and a catalogue of its library, the reports of such visitors will remain indispensible for the study of its history, and particularly for the period from the fourteenth to the twentieth century. The circumstances of monastic life there during the thirteenth and fourteenth centuries, as documented both by the monks' literary activities and the wall paintings they executed in the Old Church, were considerably better than the deplorable condition described by Wansleben who visited the monastery in 1672. In the patriarchate of John XIII (1484–1524) the monastery, abandoned and pillaged, passed into the control of the Bedouins. It was Patriarch Gabriel VII (1525–1568) who restored and repopulated the monastery, very probably in the early years of his tenure. Syrians, Ethiopians, Franciscans, and perhaps Armenians lived together with the Coptic monks in the monastery at one time or another during medieval times. Their presence enriched the cultural life of the monastery. Apparently there was a large Ethiopian community in the mid-sixteenth century. Franciscans stayed at the monastery in the seventeenth century to learn Arabic in preparation for their missionary work in the Orient and in Ethiopia in particular. During the Ottoman Period the monasteries of St. Antony and St. Macarius in Scetis were the two most significant Coptic monasteries. The former grew in importance when, in the seventeenth, eighteenth, and nineteenth centuries, most of the Coptic patriarchs were chosen from among its monks. Moreover, the monastery provided the church with outstanding bishops, some of whom were called to fill the See of Jerusalem, while others became metropolitans of the the Ethiopian Church.

Four factors determined the monastery's history: the number of its monks, the condition of its enclosure wall, the caravans from the Nile Valley, and the Bedouins. In the twentieth century, cars and paved roads brought modernity to the monastery. Simultaneously, important scholars undertook studies of its treasures. The Old Church of the monastery received serious attention and care when, in the final years of the twen-

tieth century, one of the greatest projects involving Coptic heritage was undertaken to clean and conserve its wonderful wall paintings.

The Monastery of St. Antony is famous not only because of its association with the saint, but also because of the unusually complete decorative program of its Old Church. The wall paintings represent one of the last impressive artistic achievements of the Copts before they suffered under Mamluk and Ottoman rule.

The Monastery of St. Antony (see plate 6.1) is nestled at the foot of the beautiful Galalah plateau below the mountains in Wadi Araba near the Red Sea. Although there is only a single main spring now, in medieval times three springs supplied the monastery with water. These springs are responsible for the beautiful gardens that have fascinated visitors to the monastery. A high wall surrounds most of the grounds. The greater part of the wall, to the south and west of the compound, was constructed in 1854 at the order of Patriarch Cyril IV (1854–1861). He had been a monk at the monastery and subsequently became an abbot there. The older buildings are grouped together in the monastery's northeastern section.

The monastery possesses a number of churches. But only the church known as the Old Church, or the Great Church, of St. Antony (see below) predates the mid-eighteenth century. The church of the saints Peter and Paul, often mentioned by medieval travellers, was rebuilt in 1772 by the notable Copt Lutfallah Shaker, while the Church of St. Mark, where the Franciscans were allowed to celebrate Mass in the seventeenth century, was rebuilt in 1766 by Hasaballah al-Bayadi.

There are two keeps in the monastery. The smaller is historically significant because it may well be the tower mentioned by the Coptic historian Abu al-Makarim in about 1200. It is entered at the first-floor level by a drawbridge which originally provided access from the roof of a small building opposite. The top floor of the tower contains the Chapel of St. Michael. The multistory dwellings of the monks are arranged along streets as in a settlement. That the monks inhabited an area sur-

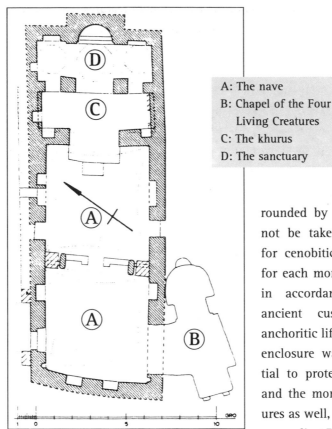

A: The nave
B: Chapel of the Four
 Living Creatures
C: The khurus
D: The sanctuary

Old Church
or the Great
Church.

rounded by a wall should not be taken as evidence for cenobitic monasticism, for each monk lived alone, in accordance with the ancient custom of the anchoritic life of Kellia. The enclosure wall was essential to protect the monks, and the monastery's treasures as well, from attack by marauding Bedouins.

The most significant building in the monastery is the Old Church of St. Antony. Nowadays the monks of the monastery believe that it is the original foundation dedicated to the great saint. Until recently, the building was assigned to the early thirteenth century. In plan it conforms to the type of long, single-nave domed church which was common from the beginning of the Fatimid Period. There are Coptic inscriptions on the walls of the church which demonstrate that the painter Theodore worked there in 1232/1233. However, during the recent excellent work of cleaning and conserving the church's wall paintings, a much older painting was uncovered on the soffit of the arch over the

doorway leading to the Chapel of the Four Living Creatures. The uncommon scene shown here of Christ in the *mandorla* flanked only by the busts of the Apostles, who are usually represented as full figures, may well have been executed as early as the seventh century.

The church comprises a nave with two successive domed bays; the present entrance is in the northern wall of the western bay. The eastern bay is followed to the east by the *khurus*, which separates the nave from the sanctuary. The eastern end of the church is occupied by three domed sanctuaries interconnected by open arches. The nave is on a lower level than both the *khurus* and these sanctuaries.

The western part of the nave is dedicated primarily to equestrian saints. There are four on the west wall to the right of the entrance. St. Theodore the Stratelate is depicted at the right, **(see plate 6.2)** riding a white horse and holding a lance, terminating in a cross, in his right hand. With it he is piercing a snake-like monster. To the left of this creature appear two youths in front of a tree, their hands tied behind their backs. The woman standing in front of the horse is probably the youths' mother, imploring the warrior saint to rescue them. The central part of the wall shows the equestrian saints Mena and Victor, son of Romanus, facing each other. St. Mena is to the right on a roan horse. Below the hind legs of the horse, St. Mena's *martyrium* is shown with a cupola in front of a camel. Another camel is under the forelegs of the horse. Two hands descending from heaven carrying a white crown flank the saint's head. Rays shine down from heaven onto St. Mena's shoulders. St. Victor is represented with a round face and riding a white horse. He holds a cross in his right hand. His *martyrium* is depicted between the forelegs of the horse. It features three domes and a chimney. Below the latter there is a window in which the bust of a figure appears. It must represent Victor, who was cast into the furnace used to heat the bath. The equestrian saint to the left is Claudius. He is mounted on a white horse and holds a lance with which he is piercing the throat of Emperor Diocletian. Claudius's *martyrium* is depicted beneath the horse's right foreleg. In the middle of an edifice there

is a door painted black; two lamps are suspended from a large arch composed of dressed stones above the door. The edifice itself is surmounted by a dome with small windows.

The north wall of the western domed bay of the nave was obliterated when the present doorway leading to the church was cut through it. Above the doorway the remains of two rider saints can be seen. Only the figure to the left has been identified (as St. Sousinius). Further to the right, two warrior saints are depicted facing each other. That on the left is St. George, riding a white horse. Behind him is a large shield. With a spear in his right hand, St. George touches the head of a small figure beneath the legs of the horse. This figure depicts a Jew wearing a turban. He carries a sack over his left shoulder and holds a golden chandelier. The scene alludes to one of the miracles of St. George. Before the forelegs of the horse, a church with an opened door, gabled roof, and a large dome is shown. The equestrian saint facing St. George is Phoibdmon. The south wall of the western domed bay was partially damaged when the arched entrance giving access to the Chapel of the Four Living Creatures was cut through it. At the west end of the wall are fragments of the equestrian saint Theodore the Oriental. To the left of the arch, the two martyred brothers Piro and Athom were shown standing. Only the head of Athom is preserved. Between the haloes of the two saints, Christ appears within a *mandorla*. He holds the Gospel in his left hand and his right hand is raised in blessing. To the left stands the priest and martyr Thouan swinging a censer with his right hand and holding a box of incense in the left. Further to the left the monk and martyr Kaau is shown holding a little figure that symbolizes a demon by the hair. It is depicted half-naked and its skin is painted black.

The Chapel of the Four Living Creatures

A large opening in the south wall of the western part of the nave leads to a room of irregular shape. It, in turn, gives access to a small *parekklesion* whose decoration features the Four Beasts of the Apocalypse. The

soffit of the arch above the door is decorated with a scene of Christ in the *mandorla* (see plate 6.3) flanked by busts of the twelve Apostles, six on each side. This, the oldest painting in the church, was discovered in the course of recent restoration work. It probably dates from the seventh century. Opposite the entrance, on the east wall, the *Deisis* (see plate 6.4) is shown. The haloed figure of Christ is represented within the *mandorla*, holding a codex in his left hand and blessing with the right, fingers and thumb touching. Four angels support the *mandorla*. The Coptic text within it reads: "Jesus Christ, Emmanuel, our God." Christ's feet rest on a semicircular hoop representing the earth. The text written on it is taken from Isaiah 66:1: "Heaven is my throne and earth is my footstool." On the sides of the *mandorla* are two groups: to the left, the Holy Virgin Mary and two apocalyptic beasts are shown with the sun above them. To the right, John the Baptist is depicted with the remaining two beasts and above them, the moon. An Armenian text under the scene reads: "Holy, holy, holy, Lord."

The Cross

A small niche under the representation of the *Deisis* is entirely filled with a scene of the cross flanked by two angels swinging censers. (see plate 6.5) The frame of the niche is decorated with two columns and an *archivolt* which is covered with a zig-zag pattern. Above the niche, on either side, is a medallion enclosing the Star of David with a cross in the middle. A semi circular hoop-like device, hung with clusters of grapes and other fruits that are difficult to identify, appears above the main tableau with the cross and angels. The remarkable cross itself is decorated with smaller medallions enclosing rosettes while the large medallion in the center is filled with a Coptic cross. A veil or scarf which features small floral designs is draped over the arms of the cross. Two medallions above the arms of the cross are inscribed with the name of Jesus. Just below them a Greek text reads "the tree of life," while the vertical inscription on both sides of the cross read "the precious cross."

The nave's eastern domed bay is decorated with portraits of the Holy Virgin Mary, enthroned with her child, and of the great figures of monasticism such as the founders of monasteries and other famous monks. These portraits, all painted *en face*, are of particular interest for the study of monastic vestments in medieval Egypt. On the southern (right-hand) wall are, from right to left: St. Pachomius; St. Barsum the Syrian, who rests his left foot on a serpent while at his right foot a pig is depicted; St. Arsenius; St. Sisoes; St. John the Little (see plate 6.6); St. Pshoi, to whom Christ appears performing a gesture of blessing; St. Samuel, with the angel of God appearing to him; St. Paul the Simple; St. Isaac the Priest; and an anonymous bishop. On the northern (left-hand) wall are shown, from left to right: St. Shenute; St. Pisentius, bishop of Coptos; St. Moses the Black; (see plate 6.7) the two Sts. Maximus and Domitius with a *mandorla* containing the bust of Christ between their heads; St. Macarius the Great, whose right hand is elevated by a cherub; another St. Macarius, and an anonymous saint. The south side of the wall separating the nave from the *khurus* shows St. Paul the Hermit on the right and St. Antony on the left, with a crow holding a loaf of bread flying towards St. Paul. (see plate 6.8) The north side of the same wall is monopolized by a scene of the enthroned Virgin holding a portrait of Christ, enclosed within a *clipeus*, in her arms. (see plate 6.9)

A program is discernible in the arrangement of these saints. The two principal figures of monasticism in Upper Egypt—Pachomius, the founder of cenobitic monasticism, and Shenute, the famous abbot of the White Monastery—face each other on the arch separating the two domed bays of the nave. The founders of the great monasteries of Wadi al-Natrun— St. Maximus, St. Domitius and St. Macarius, and Moses the Black as well—are depicted beside each other. The two saints of the site itself—St. Antony the Great and St. Paul—are the only monks depicted alongside the Virgin with Christ Child on the opposite wall.

The figures of the archangels Michael and Gabriel completely occupy the soffit of the arch leading into the *khurus*, so that their heads meet.

1.1: View from the north

1.2: Annunciation, aquarelle copy
by Pierre-Henry Laferrière

1.3:
Visitation,
aquarelle
copy by
Pierre-Henry
Laferrière

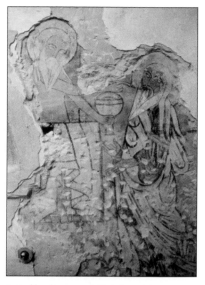

1.4: Abraham and Melchizedek

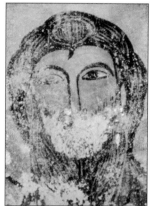

1.5:
Central
sanctuary:
Apostle
(detail)

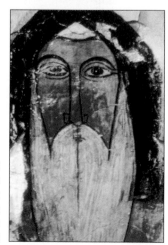

1.6:
Southern
sanctuary:
St. Barsum
the Syrian
(detail)

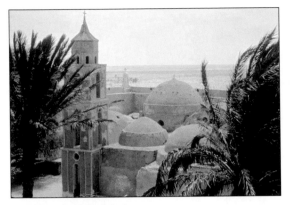

2.1: Church of St. Pshoi

2.2: Part of the residence of His Holiness Pope Shenouda III

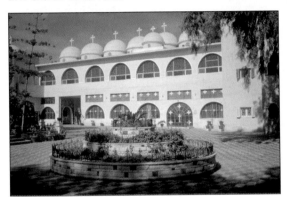

2.3: Drawbridge leading to the keep

2.4: The mill

The Monastery of the Syrians

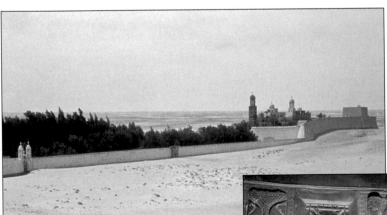

3.1: View from the north

3.2: Church of the Virgin, sanctuary: decorative stucco-work

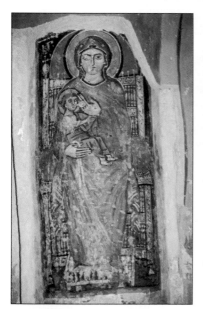

3.3: The Virgin Nursing Jesus

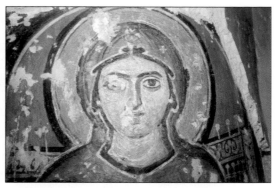

3.4: Virgin (detail)

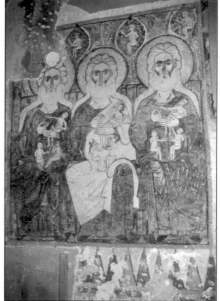

3.5:
The Three
Patriarchs

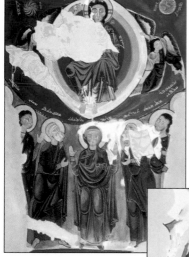

3.6: Ascension, Virgin and
Apostles, aquarelle copy
(after Leroy 1982, fig. 134)

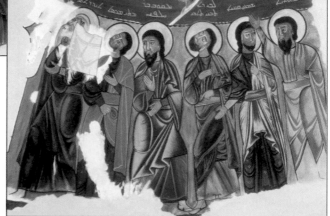

3.7: Apostles (detail),
aquarelle copy (after
Leroy 1982, fig. 134)

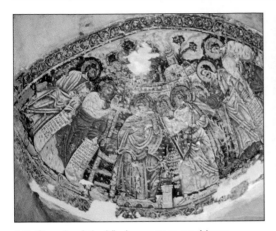

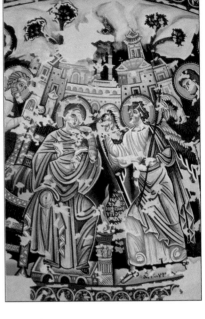

3.8: Church of the Virgin, western semidome, Annunciation

3.9: Virgin and Gabriel, aquarelle copy (after Moorsel 1995, pl.III)

The Monastery of St. Macarius

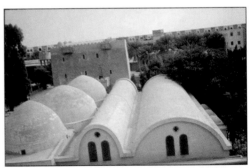

4.1: Church of St. Macarius: domes and vaults; keep

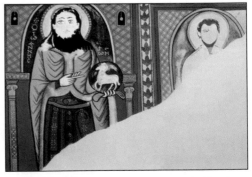

4.2: Entrance to St. Benjamin's sanctuary: Nicodemus and Joseph carrying the wrapped of body of Christ, aquarelle copy (after Leroy 1982, fig. 21)

4.3: Sanctuary of Benjamin: St. John the Baptist, aquarelle copy

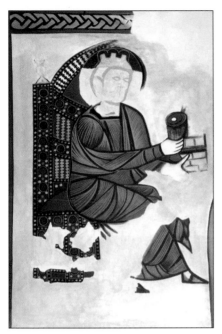

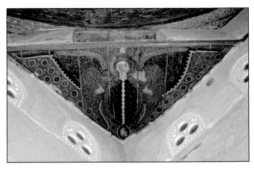

4.5: Sanctuary of Benjamin: cherub

4.4: Sanctuary of Benjamin: one of the Twenty-four Elders (Priests), aquarelle copy (after Leroy 1982, fig. 15)

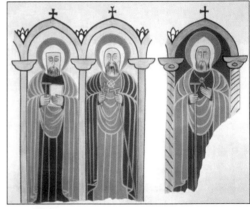

4.8: Keep, chapel of Hermits: saints, aquarelle copy (after Leroy 1982, fig. 101)

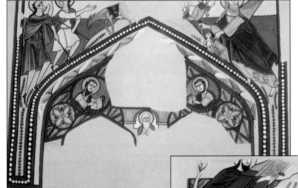

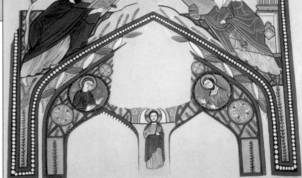

4.6: Sanctuary of St. Mark (at present dedicated to St. John the Baptist): the Sacrifice of Isaac and Evangelists, aquarelle copy (after Leroy 1982, fig. 36)

4.7: Sanctuary of St. Mark: Moses and Aaron, and Deesis, aquarelle copy (after Leroy 1982, fig. 54)

5.1: Anba Abraam

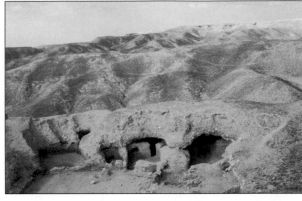

5.2: Gabal al-Naqlun: hermitage no. 44

5.4: Church of the
Archangel Gabriel:
Saint Shenute?

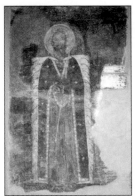

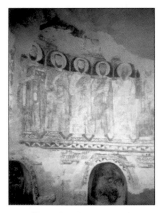

5.6: Church of Archangel
Gabriel: Apostles

5.3: Church of the Archangel
Gabriel: St. Pigoshe

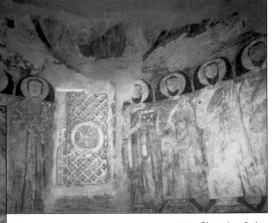

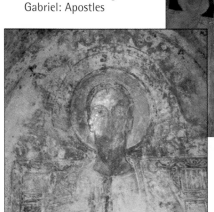

5.7:
Church of
Archangel Gabriel:
St. Mark

5.5: Church of the
Archangel
Gabriel: Apostles

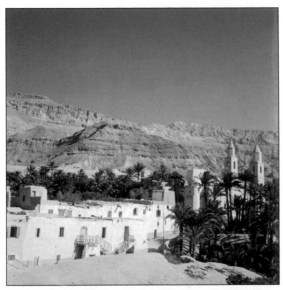

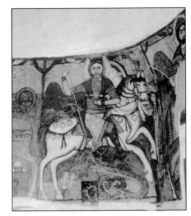

6.1: View from the northwest: the new church and the lower street (courtesy of Nabil Selim Atalla)

6.2: St. Theodore the Stratelate

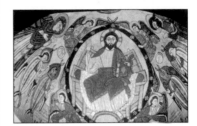

6.4: Deisis

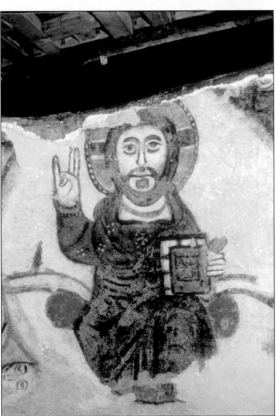

6.3: Christ in mandorla (seventh century)

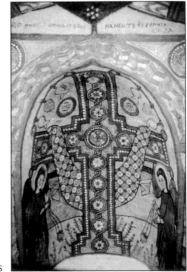

6.5: Niche of the Cross

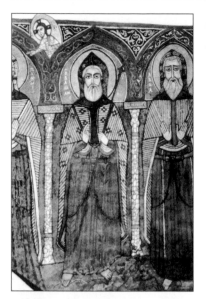

6.6 : Sts. John the Little and Sisoes

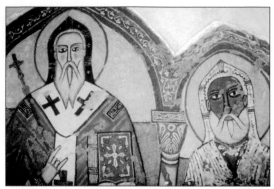

6.7: Sts. Pisentius and Moses the Black

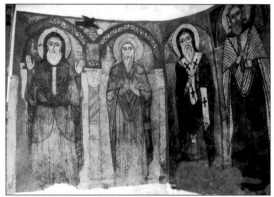

6.8: Sts. Antony and Paul (left); an anonymous bishop, and St. Isaac the priest (right)

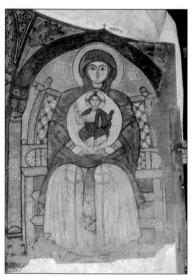

6.9: The Virgin Mary and the Child Christ (nave)

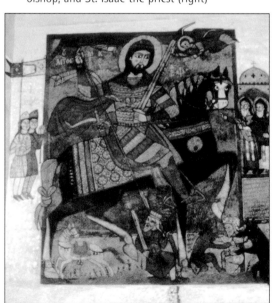

6.10: St. Mercurius

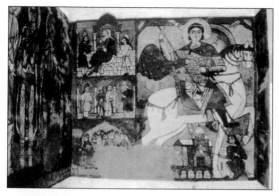

6.11: St. George

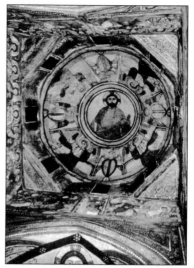

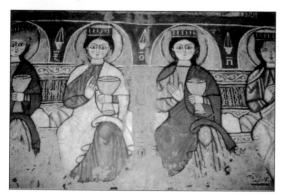

6.13: The Twenty-four Elders (detail)

6.12: Copula of sanctuary: Pantocrator, angels and cherubim

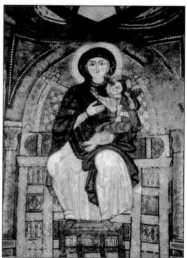

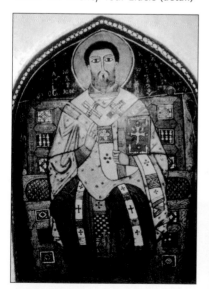

6.14: The Virgin Mary and the Child Christ (sanctuary)

6.15: St. Mark

6.16: The khurus: ceiling with arabesque

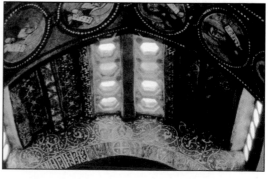

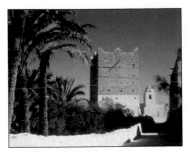

7.2: The monastery's keep and the bell tower of the Church of St. Mercurius

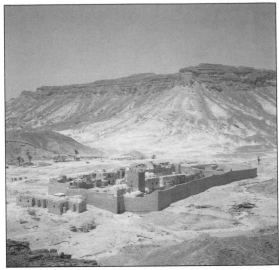

7.1: Monastery of St. Paul (courtesy of Nabil Selim Atalla)

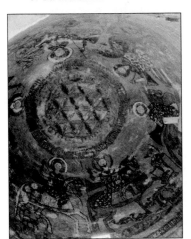

7.3: Dome of the Martyrs

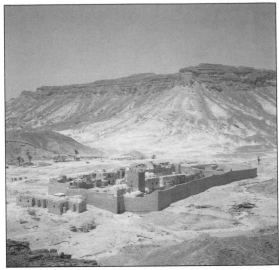

7.5: Sanctuary of St. Antony: St. John the Evangelist

7.4: Sanctuary of St. Antony: Archangel Gabriel

7.7: Sanctuary of St. Antony: an angel

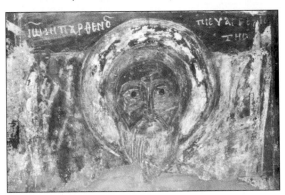

7.6: Sanctuary of St. Antony: Pantocrator

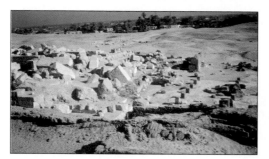

8.1: Ruins of the newly discovered monastery south of the White Monastery

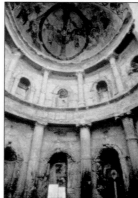

8.4: Southern semi-dome of sanctuary: columns, niches and paintings

8.2: White Monastery from the northwest

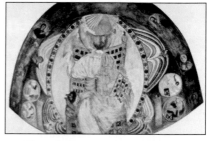

8.5: The central semi-dome of the sanctuary: Christ Enthroned, aquarelle copy

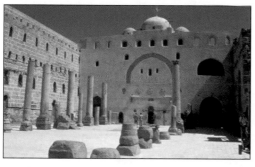

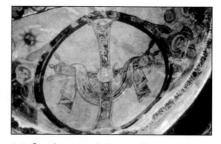

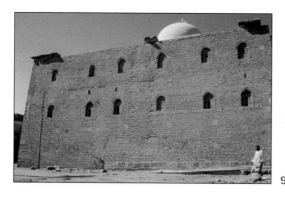

8.3: The nave of the Church of the White Monastery

8.6: Southern semi-dome of sanctuary; cross

The Monastery of St. Pshoi (Red Monastery)

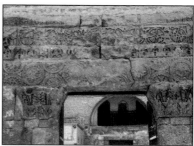

9.1: Exterior

9.2: Decorative pattern, north door

The Monastery of St. Pshoi (Red Monastery)

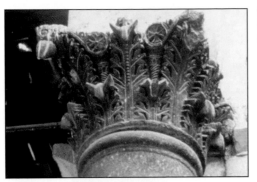

9.4: Corinthian capital

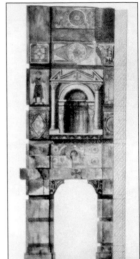

9.5: Sanctuary: aquarelle copy

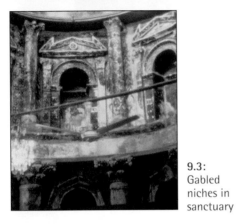

9.6: Sanctuary: Apa Theophilus, aquarelle copy

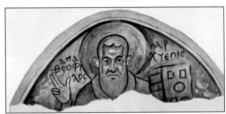

9.3: Gabled niches in sanctuary

The Monastery at Qubbat al-Hawa

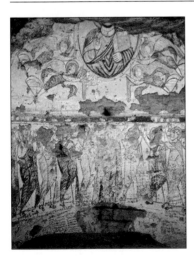

10.1: Qubbat al-Hawa

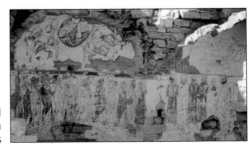

10.3: Christ in mandorla supported by angels

10.2: Apse and vaulted long room with paintings

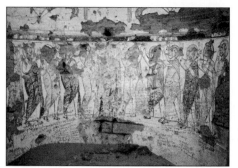

10.4: Virgin Mary flanked by apostles

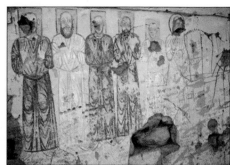

10.5: Monastic saints with square halos

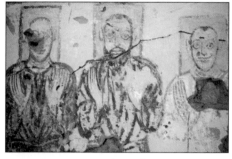

10.6: Monastic saints (detail)

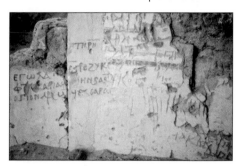

10.7: Coptic text with the date of AM 896 (1180 CE)

The Monastery of Saint Hatre (St. Simeon) at Aswan

11.1: View from the southwest

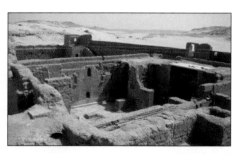

11.2: The church and northeast corner of the parapet walk

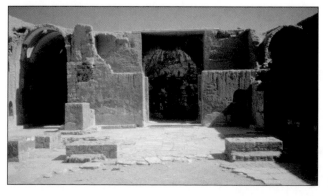

11.3: The church

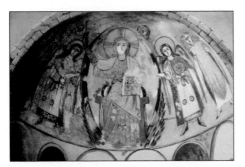

11.4: Sanctuary: Enthroned Christ flanked by two angels, aquarelle copy

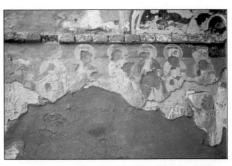

11.5: North wall of the sanctuary: Twenty-four Elders

11.6: Grotto: saints

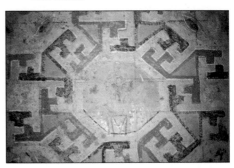

11.7: Grotto: ceiling decoration

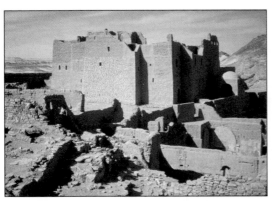

11.8: The keep

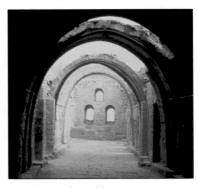

11.9: Vaulted corridor

11.10: Cell with stone beds

11.11: The refectory

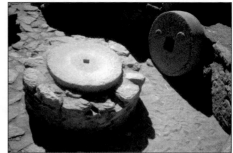

11.12: The oil press

The Monastery of St. Apollo at Bawit

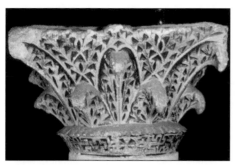

12.1: Composite capital

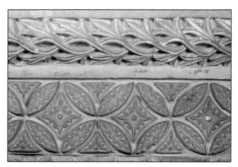

12.2: Superimposed friezes with ornamental foliage and geometric designs

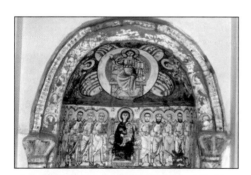

12.3: Christ in the Majesty, Virgin and Child flanked by apostles and saints

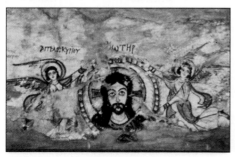

12.4: Bust of Christ "the Savior" carried by two angels

12.5: Christ (detail)

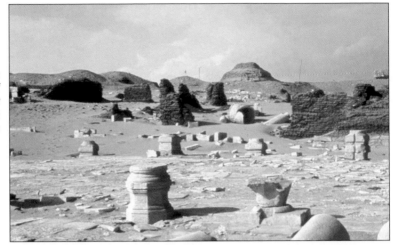

13.1:
Ruins of
the Monastery
of St. Jeremiah
at Saqqara

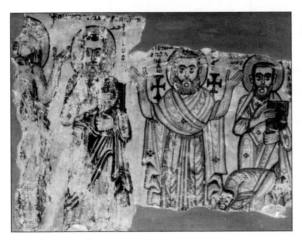

13.5: Saints and a penitent

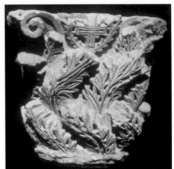

13.2: Wind-blown capital

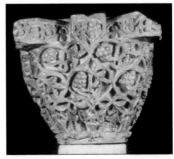

13.3: Basket capital

13.4:
Frieze with
cross and
scrolls
enclosing
animals
and busts

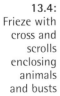

Michael, on the north side, and Gabriel, to the south, are represented as the guardians of the entrance. They are quite similar, except for the color of the garments they wear. Depicted full length, each grasps a spear surmounted by a cross with the right hand and, with the left, a sphere which figures a monogram of Christ. Their wavy hair falls to their shoulders. The archangels' costume is richly ornamented with extraordinarily bright colors. On the south wall of the *khurus* a scene depicting the martyr and saint Mercurius on a horse is depicted. (see plate 6.10) In his left hand he grasps a sword which is supported by an angel in full flight. With a lance surmounted by a cross in his right hand, Mercurius impales Emperor Julian the Apostate. Julian's horse, at the left, looks toward him. Parts of the horse's harness, such as the bridle and the breast strap, are skillfully painted. Beneath the left foreleg of the horse the two *cynocephali* (a man with the head of a pig or a dog) Ronfos and Sorkane torture the saint's grandfather. To the right of the horse, Bishops Basil and Gregory are depicted within a domed building. Below them the famous text that dates the painting is inscribed: "AM 949" (1232/3 CE).

The southern part of the west wall of the *khurus* shows a scene of the three Old Testament patriarchs Abraham, Isaac, and Jacob with the blessed in paradise. Their faces are schematically rendered but their names are clearly discernible on the right armbands of their tunics. The pallia they wear are decorated with small crosses. The patriarchs share a bench and on their left arms they carry the souls of the blessed, who are depicted as infants holding, picking, or eating fruits. Beside the haloes of the patriarchs, other figures are shown picking fruits from the trees. This scene is related to a passage in the *Difnar*, a liturgical text which contains the only Coptic reference to the consecration of the Church of St. Antony in the Wadi Araba. The first sentence of this text reads: "May God who was with our fathers Abraham, Isaac, Jacob, and Moses be with us today!"

On the north wall of the *khurus* is a scene showing the equestrian saint and martyr George, mounted on a white horse. (see plate 6.11) A hand descends from heaven on either side of his head. The hand on the

left holds a crown and the hand on the right is making a gesture of bless-
ing. Behind the saint is a shield decorated with a cross. With his right
hand, St. George grasps a spear surmounted by a cross with which he is
piercing Euhius, the wicked soldier who was sent to destroy the saint's
sanctuary. In front of Euhius and beneath the horse there is a represen-
tation of the church with a gabled roof, a dome, and an altar surmount-
ed by a cross. At both entrances of the church a lamp appears. In front
of St. George, on the eastern wall of the *khurus* and just to the left of the
entrance leading to the northern sanctuary, three little scenes are paint-
ed that relate to the saint's *martyrium*. In the upper register, an inscrip-
tion identifies him by name. The middle register shows a man wearing a
turban who, according to the text, is writing or describing the *martyri-
um* of the saint. In the lower register, two of the martyr's executioners
carry his body. Behind St. George there is a scene representing King
Nebuchadnezzar enthroned on an x-shaped seat beneath a baldachin
which is supported by two columns. A lance-bearer stands on either side
of the baldachin. The lower register is occupied by a triple *arcature*. Each
of the lateral arcades shelters a lance-bearer while two centurions stand
below the central arch. The scene of Nebuchadnezzar is related to the
large tableau of the Three Hebrews in the fiery Furnace, which is paint-
ed just to the left, on the northern side of the east wall of the *khurus*.
They are depicted in an attitude of prayer and wearing Phrygian cos-
tumes. A fourth person wearing a long tunic and a *pallium* holds a long
staff in his right hand, extending it across the Three Hebrews.

On both sides of the archway leading from the *khurus* to the central
sanctuary there are scenes associated with the Resurrection. The first, at
the right, depicts the women who came to the tomb to anoint Christ's
body. The second scene, at the left, represents the risen Christ appearing
to the two Marys. In the first scene a seated angel greets the three women.
Two of them carry bottles in their left hands and the third woman has
thrown up her hands in astonishment. In the second painting at the left,
Christ is shown with a crossed nimbus. He holds a codex in his left hand

and his right is raised in blessing. The first woman kneels at Christ's feet. Apparently this figure was added to the scene some time after it had been completed. The second woman stands behind her and is stretching out her hands towards Christ. These scenes display a different style than those executed by Theodore. Their anonymous painter was probably active in the fourteenth century, and he might also have been responsible for repainting the scenes on the walls of the western part of the nave.

The church has a tripartite sanctuary with open arches connecting its three segments. The soffit of the archway leading from the *khurus* to the sanctuary is decorated with busts of the prophets Moses, David, Daniel, Isaiah, Elijah, and Jeremiah within medallions. The cupola of the sanctuary shows a bust-length image of the Pantocrator surrounded by alternating angels and cherubim. (see plate 6.12) Alongside three of the four angels there is a Coptic text which reads "Glory be to God on high." Beside the cherubim depicted at the eastern side, "Holy, holy, holy" is written in Greek. The octagon figures another eight adoring angels.

Sanctuary: distribution of the paintings (after van Moorsel 1995 b, fig. 7)

A frieze seventy centimeters high surmounts the upper zone of the four walls which support the octagon. It is filled with representation of the Twenty-four Elders, or "Priests," of the Apocalypse. (see plate 6.13) Each of them is depicted as a beardless youth, seated and holding a chalice in the left hand. Above the main altar and below the scene of the Twenty-four Priests, the painter executed four scenes from the Old Testament. Two are painted on

the north wall: the Seraph cleansing Isaiah's lips with a glowing coal, and the Meeting of Abraham and Melchizedek. The south wall shows the Sacrifice of Abraham and the Sacrifice of Jephtah. With his left hand, Abraham is grasping Isaac by the hair and he is about to touch his son with the knife in his right hand. Abraham's face is turned towards the hand of God. Below the ram, tied to a flourishing tree, there is a Coptic

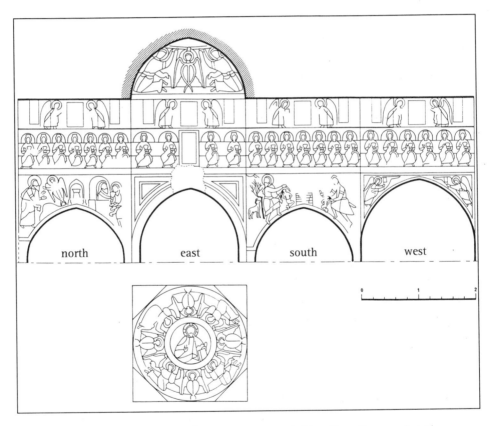

Cupola of the sanctuary: Pantocrator surrounded by alternating angels and cherubim; below, all around the sanctuary: the Twenty-four Elders of the Apocalypse; north wall: the Seraph cleansing Isaiah's lips, and the Meeting of Abraham and Melchizedek: south wall: the Sacrifice of Abraham and the Sacrifice of Jephtah; west wall: two angels (after van Moorsel 1995 b, fig. 8)

inscription written by the painter Theodore in which he describes himself as the son of Gabriel, bishop of Itfih. Since Gabriel is known to have been bishop in 1216, this inscription furnishes a date for the painting. To the right is shown the Sacrifice of Jephtah, who is represented clutching his daughter's hair with his left hand and grasping a knife in the right. The occurence of this Old Testament scene (Judges 11:30–40) in the paintings of the Old Church is unique in Coptic art. In Egypt the theme is otherwise only found in the paintings of the Greek Orthodox Monastery of St. Catherine in Sinai.

The main apse of the Old Church is decorated with the usual two-zoned composition of the enthroned Christ within the *mandorla*, above, and the enthroned Virgin with Child, below. The treatment of the scene of the Christ in the *mandorla* is similar to the rendering in the Chapel of the Four Living Creatures. A red hand separates this zone from that below, where the Virgin is enthroned on a cushion with her feet resting on a footstool. She holds the infant Christ on her lap. **(see plate 6.14)** Two angels flank Mary. Michael, on her right, is the better-preserved figure. The niche of the north sanctuary, at the left, is monopolized by the portrait of St. Mark whom the associated text describes as "St. Mark, apostle, evangelist, and martyr." **(see plate 6.15)** He is depicted as a relatively young man, seated and holding a codex decorated with a cross in his left hand. Unlike the other saints, Mark was never a monk, which explains why he does not wear the monastic hood (*kalansuwa*). The niche of the south sanctuary is dedicated to St. Athanasius (326–373), the most important patriarch of the Coptic Church. He is represented seated, like St. Mark, and holding a codex with a cross in his left hand. Two patriarchs are depicted on the east wall above St. Athanasius. To the left St. Severus of Antioch (c. 465–538) is shown standing and also holding a codex in his left hand which figures Christ within the *mandorla*. As is well-known, St. Severus is highly venerated in the Coptic Church. To the right Patriarch Dioscorus (444–458) is standing and holding a codex decorated with a cross. The south wall of this sanctuary shows the por-

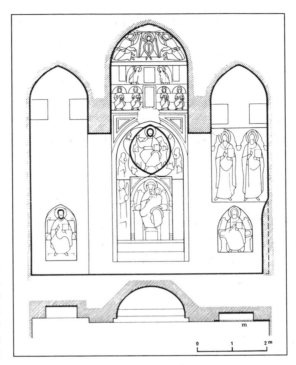

Sanctuary: east wall, main apse: Enthroned Christ (above), Virgin and Child (below); north niche: St. Mark; south niche: St. Athanasius, Saints Severus of Antioch and Dioscours (upper register) (after van Moorsel 1995 b, fig. 13)

traits of three patriarchs: Theophilus (385–412), Peter (I: 300–311 or II: 373–380) and an anónymous patriarch, probably Cyril (412–444).

Several arches in the church and the barrel vault of the *khurus* show beautiful foliated arabesque and other floral design. **(see plate 6.16)**

The famous cave of St. Antony cannot be seen from the monastery. It is located about 370 meters above the grounds and can be reached in about half an hour of steep climbing from the monastery's gate.

Bibliography

Bolman, in press; Brown 1981, p. 80 f.; Coquin/Laferrière 1978; Gabra, in press (a); Grossmann 1991c; idem 1995; Leroy 1976a; van Loon 1999, pp. 83–108; Meinardus 1992, pp. 5–32; van Moorsel 1991a; idem 1995b; Timm III, pp. 1287–1330; Walters 1974, pp. 90 f., 302–309.

The Monastery of St. Paul

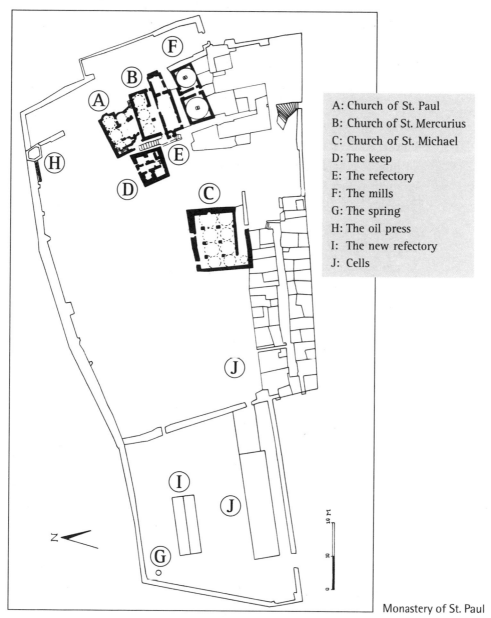

A: Church of St. Paul
B: Church of St. Mercurius
C: Church of St. Michael
D: The keep
E: The refectory
F: The mills
G: The spring
H: The oil press
I: The new refectory
J: Cells

Monastery of St. Paul

The Monastery of St. Paul, "Dayr Anba Bula," (see plate 7.1) is located about thirty-nine kilometers southwest of the Red Sea lighthouse station of Za'farana. It is hidden away in the wilderness of the mountainous desert west of the Red Sea. The monastery bears the name of its patron, St. Paul, presumably Paul of Thebes, whose biography was composed by St. Jerome probably in 375/376. St. Paul withdrew into the Eastern Desert in about 250 to escape the persecution of the Emperor Decius. According to one tradition he lived in an underground cave for almost ninety years. Shortly before his death, about 340/341, St. Antony visited him. It is said that after the death of St. Paul two lions dug out the grave in which St. Antony had buried the holy corpse. In the course of time the cave of St. Paul became a pilgrimage site and developed gradually into a monastery. The cave was first mentioned in 401 by Sulpicius Severus. He speaks of the journey of Postumian, who visited Egypt, including "the place in which the blessed hermit Paul lived." In 570 an anonymous pilgrim from Placentia visited the "cave of the blessed Paul" and noted only the spring. Abu al-Makarim (twelfth century) states that the monastery was in the desert near the pool of Mariam and that monks came from the Monastery of St. Antony to celebrate the liturgy in it by turns. Beginning in the fourteenth century many European travelers reported on the Monastery of St. Paul. In 1395 Ogier de St. Chéron, Signeur d'Anglure, found sixty monks there. Al-Maqrizi (d. 1441) called it the monastery of the tigers. The monastery was abondoned and sacked by the Bedouins during the patriarchate of John XIII (1484–1524). Patriarch Gabriel VII (1525–1568) repopulated the monastery, but the Bedouins sacked it again during his lifetime. The monastery remained in ruins and was probably uninhabited for more than a century. It was Patriarch John XVI (1676–1718) who restored and repopulated it in the early eighteenth century. In the eighteenth century three patriarchs— Peter VI (1718–1726), John XVII (1726–1745) and Mark VII (1745–1769)—withdrew as young men to the Monastery of St. Paul for some years. The abbots of the Monastery of St. Antony administered the

Monastery of St. Paul for most of its history. In 1974 Pope Shenouda III consecrated Bishop Agathon to supervise the monastery.

Although some scholars visited the monastery in the nineteenth and the twentieth centuries, it was not until the 1970s that serious studies on it began to appear. Recently a part of the monastery's ancient buildings, including the refectory, two mills, and a part of the outer walls, were skillfully restored.

There are four churches at the Monastery of St. Paul. The Church of St. Paul, also known as the Cave of St. Paul, is the most sacred part of the monastery. In 1781 a church dedicated to St. Mercurius (Abu Saifain) was built by Ibrahim al-Gawhari, a notable Copt. This church is above the Church of St. Paul and contains a rock-cut staircase descending to the latter. In 1727 Patriarch John XVII built the Church of St. Michael, which is the largest church within the grounds of the monastery. The fourth church is that of the Virgin Mary, which is situated on the fourth floor of the monastery's keep. (see plate 7.2)

The old Church of St. Paul is the most attractive monument in the monastery. It occupies the site of the cave, into which Paul, the patron saint of the monastery, withdrew. The architecture and decoration of the church are unusual. The oldest part of the church is mainly underground and carved into the rock. It consists of the sanctuary of St. Paul (H) and his cenotaph (G). None of them now contain paintings. Later this old part of the church was enlarged, and a nave (C), a sanctuary dedicated to St. Antony (F), and a corridor with a staircase (D) were dug out. The earliest preserved wall paintings here date from the thirteenth and fourteenth centuries. In 1713 or 1714 Patriarch John XVI (1676–1718) restored the existing cave church and extended it with three domed rooms constructed of stone blocks on its north side (A, B, E). A new staircase was created in the westernmost room (A). The church is now accessible via this staircase. In the eighteenth century a monk of the Monastery of St. Paul executed the paintings which are in the church's new extension. He also repainted some of the old existing scenes or the paintings which had

faded away. Despite his inexperience and simple techniques, such as using a compass to draw the faces or working without preparing any background, his multicolored scenes are not without interest. They are full of individuality and show the Coptic iconographical tradition of a monk of the eighteenth century in this remote place. It has to be remembered that monastic wall painting had been almost unpracticed in Egypt for a long time before these paintings were executed. **(see plate 7.3)** The following list of the paintings and their distribution in the cave church are taken from Lyster 1999, pp. 44 and 45:

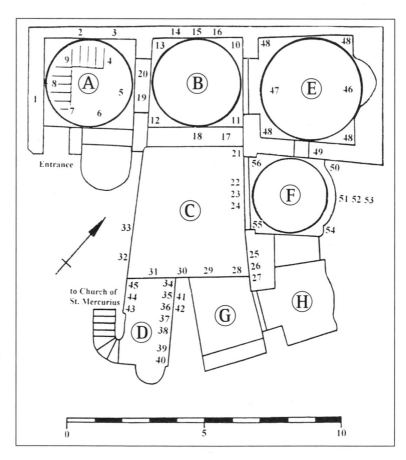

Cave Church:
Monastery
of St. Paul

A. Dome of the Martyrs
Stairwell:
1. St. Victor of Asyut, martyr
2. St. Theodore the Stratelate, martyr
3. St. George, martyr

Dome:
4. St. Theodore the Oriental? martyr
5. SS. Apater and Eirene, martyrs
6. St. Isidore of Antioch, martyr
7. St. Abiskhirun of Qalin, martyr
8. St. James al-Muqatta, martyr
9. St. Mena, martyr

B. Nave (north)
10. St. Gabriel, archangel
11. St. Suriel, archangel 12.
St. Raphael, archangel
13. St. Michael, archangel
14. St. Sarapion, bishop
15. St. Antony, father of monks
16. St. Paul, first hermit
17. St. Eirene, martyr
18. St. Marina, woman-monk
19. St. Julitta, martyr
20. St. Cyriacus, martyr

C. Nave (center)
21. St. Marqus, monk
22. Virgin Mary (ceiling)*
23. Jesus Christ (ceiling)*
24. St. John the Baptist (ceiling)
25. St. Maximus, monk
26. St. Domitius, monk
27. St. Macarius the Great, monk
28. Angel with Child (ceiling)*
30. St. Moses the Black, monk
31. Virgin and Child with Cherubim
32. SS. Michael, Gabriel, and Raphael
33. Three Youths with Angel

D. Corridor
34. Unidentified monk
35. St. Arsenius, monk
36. St. Abib, monk
37. St. Apollo, monk
38. St. John the Little, monk
39. Unidentified monk
40. Unidentified monk
41. St. Bishoi, monk*
42. St. Shenouda, monk*
43. St. Samuel of Qalamun, monk
44. St. Julius, monk
45. Unidentified monk

E. Haykal of the Twenty-four Elders
46. Christ Pantocrator with the Four Living Creatures
47. Seven Angels with Trumpets
48. Twenty-four Elders

F. Haykal of St. Antony
49. St. John the Evangelist (13th cent.)
50. Angel (1334)
51. Christ Pantocrator with the Four Living Creatures (1334)
52. Annunciation: Virgin Mary and Archangel Gabriel (13th cent.)
53. Theotokos (mother of God) with Two Angels (13th cent.)
54. Angel (1334)
55. Seraphim (1334)
56. Seraphim (1334)

G. Nave (south) and Cenotaph of St. Paul

H. Haykal of St. Paul

NB. All paintings are from c. 1713 unless otherwise noted.
* = Paintings from the 13th or 14th century

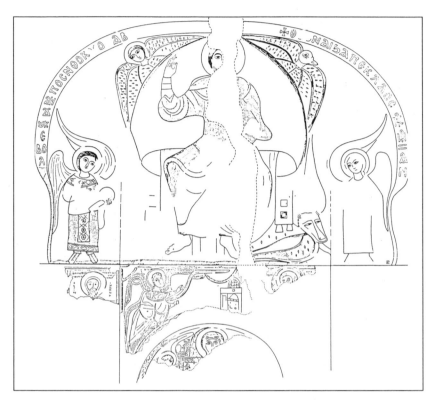

Sanctuary of St. Antony, east wall (after van Moorsel 1994, fig. 6)

Some of the earliest paintings in the cave church are of special
significance. Above the entrance of the sepulchral chamber of St. Paul (G)
are the remains of a Coptic text referring to a scene which should have
represented the Magi and Herod. On the flat ceiling at the left of the
entrance to this chamber, a flying angel carrying a child is depicted. It has
been suggested that the scene represents Uriel protecting the child John at
the time of the Massacre of the Innocents. If so, more episodes from the
cycle of the infancy of Jesus and John may have been depicted above the
entrance of the cenotaph of St. Paul. The decoration of the east wall of the
sanctuary of St. Antony (F) is unusual. It is decorated with a combination
unique in Coptic art. In the niche there is a depiction of the Enthroned

Mother of God "Theotokos" between two angels and, just above them, an Annunciation with Gabriel in the left spindrel, (see plate 7.4) the Virgin in the right, and the spring of Nazareth in the middle. On the adjacent northern wall St. John the Evangelist is shown, though now only the saint's head remains. (see plate 7.5) These scenes were painted in the first half of the thirteenth century. In 1333–1334 (AM 1050) a scene of the majestic Pantocrator was painted above the scene of the Annunciation. The Christ Pantocrator (see plate 7.6) is surrounded by the four creatures of the apocalypse and flanked by two angels. (see plate 7.7) Pantocrator is shown within a *mandorla* with a striking sky-blue color.

The monastery of St. Paul is supplied by two sources of water. The spring of St. Paul is within the southern extension of the walls. The second spring is the pool of Mariam, which is a few hundred meters south of the monastery. There are other buildings in the monastery grounds which had been restored, enlarged, or renovated over the centuries. Serious archaeological and architectural investigations are required to appreciate and date important constructions such as the outer walls, the keep, the refectory, and the two millrooms. They preserve the atmosphere of medieval monuments. The study of the library's manuscripts (891 volumes) might provide valuable information to fill the many gaps in the long history of this monastery.

The Monastery of St. Paul is significant for the fact that it bears the name of the first Hermit. It was established on the very spot, deep in the desert, where, according to tradition, the two great figures of monasticism, St. Paul and St. Antony, met. The architecture and the decoration of the old Church (the cave church) of St. Paul are exceptional.

Bibliography

Brown 1981, p. 82; Coquin and Martin 1991; Guillaumont and Kuhn 1991; Leroy 1978; Lyster 1999; Meinardus 1967–1968; idem 1992, pp. 33–47; van Moorsel 1991b; idem 1994; idem 1995c; idem, in press; Timm III, pp. 1359–1373.

The Monasteries
of Sohag

S
ources speak of the monasteries which Pachomius established in the neighborhood of Akhmim during the first half of the fourth century. But no physical trace of them has been found, nor can hypothetical locations be proposed for them on present evidence. Many monasteries, however, still exist in the district of the ancient town of Akhmim (Panopolis), which lies about five hundred kilometers south of Cairo on the east bank of the Nile. Only a few of them—such as the Monastery of the Archangel Michael and that of al-Shuhada—are of historical interest. The most celebrated monasteries in the Akhmim region are undoubtedly those which St. Shenute dominated in the fourth and the fifth centuries. Shenute became a monk in about 370 in the White Monastery, which had been founded by Shenute's uncle Pjol. After the death of the latter in about 385 Shenute became the abbot of the monastery. Shenute, the most significant Coptic writer, led the struggle against adherents to the old religions and destroyed their temples in the area. Because of his reputation, Patriarch Cyril invited Shenute to attend the Council of Ephesus with him in 431. Shenute died in 464 or 465.

The Monastery of St. Shenute

The Monastery of St. Shenute, known as the White Monastery, is located on the edge of the cultivation in the Libyan desert, about eight kilometers to the west of the city of Sohag. The monastery is very close to

the ancient village of Atripe, where Christianity existed long before Shenute. Hermits knew the mountain of Adribah (Atripe) perhaps prior to the beginning of the fourth century. But it was under the leadership of St. Shenute that the monastery grew considerably. We know from literary sources that the domain of the monastery expanded during his tenure. The compound covered approximately ten square kilometers, with several dependent communities and thousands of monks and nuns. The remains of monastic buildings belonging to one of these communities, which lies three kilometers south of the White Monastery, have recently been discovered. (see plate 8.1)

Sources speak of 2,200 monks and 1,800 nuns, accommodated two per cell, associated with the White Monastery. The Monastery of St. Shenute became the most important religious center, and, in some respects, social institution in the region of Akhmim. The acts of philanthropy of the monastery were many, especially in times of famine. When the Blemmye/Beja tribes attacked inhabitants of Upper Egypt in Shenute's days, the monastery took in twenty thousand men, women, and children, who were fed and clothed. The sick were cared for and the dead received proper burial. The medieval codices of the large and significant monastic library have been dispersed piecemeal among several museums and libraries in many countries. It is worthy of note that the codices of Shenute's works have been reconstructed from about 1,870 extant leaves, which represent only a fraction of what may have once amounted to as many as 25,000 pages.

The immediate successor to Shenute was his biographer Besa, who spent considerable time as a monk under his tutelage. Besa died some time after 474. He was followed by Shenute's secretary Zenobios. Some of the monastery's abbots are mentioned in papyri from the fifth to the eighth centuries and in the *History of the Patriarchs*. The colophons of several manuscripts from the tenth to the thirteenth centuries provide significant information about the monastery, especially the names of abbots. Two of these colophons refer to the Ghuzz troops, who, accompanied by Shirkuh

(a Fatimid vizier), invaded Egypt and pillaged the monasteries in 1167. The church historian Abu al-Makarim (early thirteenth century) also mentions this event, and he recorded that the bodies of the apostles Bartholomew and Simon the Zealot were preserved in the monastery. Abu al-Makarim mentioned the Armenian vizier Bahram (1135–1137), who withdrew to the White Monastery. The Armenian inscriptions in the apse of the church reflect the influence of the Armenian community in Egypt, especially during the Fatimid Period. By the time of al-Maqrizi (d. 1441) the monastery lay in ruins, except for the church. For some time in the sixteenth century an Ethiopian community apparently lived at the monastery.

The church must have stood within a walled enclosure which covered a large area and included the cells of the monks, bakehouses, kitchens, and other facilities. In 1908 a small part of this mud-brick enclosure wall, which surrounded the monastery, was unearthed. In the 1980s excavations were carried out at the site of the monastery. A lodging house of several stories with halls for the accommodation of the monks and for storage was discovered to the west of the church. Another building with four pillars, which probably served as a refectory, was found, as well as a large kitchen and, perhaps, latrines. Two ceramic vessels filled with hundreds of Byzantine coins numbered among the notable finds. Many of the coins bear the name of the Emperor Phocas (602–610).

The Church

This imposing structure is the most important Christian monument in Upper Egypt. There is little room for doubt that it was founded by Shenute himself and that it dates to before the middle of the fifth century. The block-like appearance of the church's exterior resembles an ancient Egyptian temple. (see plate 8.2) The external walls are built of limestone blocks of considerable size with a few granite slabs. The walls are crowned with the Egyptian cavetto cornice that is also used for lintels above doorways. Two rows of recesses like windows are seen in the external walls. The church is entered through a gate in the southern wall,

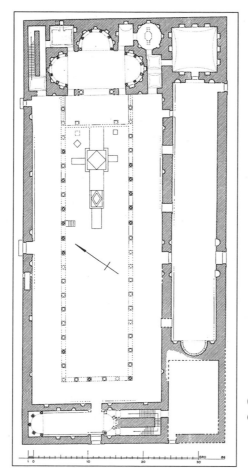

Church of the Monastery
of St. Shenute

gate in the southern wall, which leads to the so-called southern or later-
al narthex with an apse at its western side and a square room at its east-
ern side. The function of this great hall is not known; perhaps it was a
chapter house. The church has a western narthex, which is reached from
the nave by a door. The nave is separated from the two side aisles by two
rows of columns; a return aisle is at the west end of the nave. The steps
of an *ambon* stand at the north aisle. The sanctuary features a *triconch*
flanked at the north side by a staircase and at the south by an octago-

the remains of a baptismal basin and a small subterranean domed structure, which was probably used as a tomb. Apparently the small square room to the north of the apse was the library. Inscriptions were found on its four walls which give the titles of books, sometimes accompanied by a notation of the number of copies of it on hand at the time. Some of these inscriptions date from the twelfth and thirteenth centuries. The library contained biblical, homiletic, hagiographic, and historical texts. It is noteworthy that there were more than a hundred copies of the four Gospels, twenty copies of the *Life of Pachomius*, and eight copies of the *Life of Shenute*.

At some point between the sixth and the eighth centuries, perhaps during the Persian occupation of Egypt (619–629), a fire caused serious damage in the church. Apparently only a few years later it was rebuilt according to the original plan in baked bricks instead of ashlar construction. The lost columns of the nave were, unusually, rebuilt with ordinary baked bricks. At a later time, about the ninth century, a *khurus* was added in front of the sanctuary. The domed vaulting over the center of the sanctuary was installed in the middle of the thirteenth century, and that over the *khurus* even later. The architectural sculpture of this church is of considerable significance. **(see plate 8.3)** It comprises more than forty profusely ornamented niches with semi-columns, or pilasters, capitals, bases and gables, as well as the entablatures and cornices of the *triconch*, bases and capitals of the portals and of the apse of the narthex, and more than two hundred and forty meters of running cornice of various architectural elements. The rich decoration of the church incorporates older, unchanged reused pieces, older pieces that have been more or less reworked, and new pieces that were created specially for the church. When the parts of the church which had collapsed were rebuilt, elements from the original building were used alongside pieces from other sources. All the granite elements derive from older buildings. A great amount of the high quality limestone architectural sculpture was made especially for the church in about the middle of the fifth century.

The fact that these beautiful elements decorate several parts of the church indicates that the impetus to employ older pieces alongside them was not merely economical or the result of lack of artistic ability. It has to be remembered that Shenute, the founder of this church, led attacks against previous religions. The reuse of elements taken from non-Christian temples demonstrates the triumph of Christianity.

The church has at least six entrances, all of which seem to be original. There are three primary entrances, in the north, south, and west walls. The south entrance incorporates a reused granite lintel decorated with a cross set within a circle and supported by two doorjambs made of several decorated pieces of limestone. At the north end of the narthex there is a semicircular apse with five columns carrying an architrave. The long side walls of the narthex are decorated with niches. Some of the niches are richly ornamented, supported by two pilasters with a foliate motif and surmounted by a broken gable, which is separated from the niche itself. A considerable number of capitals for columns were found in the church; many of them have been reused. Some are Corinthian style and others are Ionic. The cornices are elaborately decorated with floral motifs, the architraves with grape clusters, rosettes, large leaves and geometric designs. The decoration of the triconch sanctuary deserves special attention. It features columns with entablatures and cornices in two rows in front of the wall. (see plate 8.4) The intercolumnar sections of the wall behind are ornamented with wall niches. The magnificent architectural sculpture of the sanctuary is the result of many repairs and the insertion of foreign material into the original decoration. The semidomes of the triconch sanctuary are decorated with paintings. The central semidome shows Christ enthroned within the *mandorla*, from which protrude the winged symbols of the Evangelists. (see plate 8.5) Christ holds a book in his left hand and raises the right in blessing. A shell motif appears above the head of Christ. The four Evangelists are depicted writing their Gospels within medallions at the edges of the semidome. Decorative panels are inserted between them. The medallions that decorate the arch soffit contain the Holy Virgin

Mary (top left), St. John (top right), and angels. The Coptic and Armenian texts accompanying the painting name the artist (Theodore) and date it to 1124 CE. The southern semidome is decorated with a scene representing the cross flanked by the *Deisis*. It shows a large draped cross set within an oval frame which is supported by two winged angels. The arms and the central junction are decorated with medallions containing small crosses. (see plate 8.6) The figures of the Virgin and St. John, with the sun and moon above, flank the cross. A series of medallions occupied by alternating crosses and busts of prophets frame the entire scene. The paintings in the northern semidome of the sanctuary have largely been destroyed. However, it is hoped that a project to clean and restore the wall paintings of the Church of St. Shenute will begin in the near future.

The Monastery of St. Shenute bears the name of a great figure of monasticism and one of the most distinguished personalities of the Coptic Church. During his time the monastery played a crucial religious, cultural, and social role in the region of Akhmim. The architecture of the monastery's church influenced church building in this region. The splendid architectural sculpture of the church is invaluable for the study of early Christian art in Egypt. The precisely dated paintings of the sanctuary are of considerable importance for further research on the monastic painting of medieval Egypt. The manuscripts from the library of the White Monastery preserve a significant part of the Coptic literary heritage.

Bibliography

Akermann 1977; Badawy 1978, pp. 73, 75, 182, 272; Coquin 1991b; Coquin and Martin 1991c; Dadoyan 1996; Elm 1994, pp. 296–310; Emmel 1999; Gabra, in press; Grossmann 1982, esp. pp. 115, 119 f.; idem 1985a; idem 1991j; idem 1998a, pp. 443–449; Hunt 1985, p. 115; Krause 1991; idem 1998, p. 158 f.; Mohamed and Grossmann 1991; Monneret de Villard 1925/26; Sauneron 1974, pp. 206 f; Severin 1991b; idem 1998, pp. 311–315; Timm II, pp. 601–634; Walters 1974, pp. 309–311.

The Monastery of St. Pshoi

The Monastery of St. Pshoi is situated within the village of Nag' Abu Azizah about three kilometers north of the Monastery of St. Shenute. It is known as the Red Monastery because of the color of its external walls, which were built of baked bricks. (see plate 9.1) Over the centuries this monastery stood in the shadow of the famous Monastery of St. Shenute. Therefore information about its history is relatively rare. It is not known whether St. Pshoi, whose name the monastery bears, was actually its founder or whether it was merely built in his honor. However, St. Pshoi was an older companion of St. Shenute. Both saints and Pjol, Shenute's maternal uncle, built three cells in the mountain and a church, which they called al-Raghamah. The latter might have been located about three kilometers south of the Monastery of St. Shenute, where the remains of monastic buildings have recently been discovered. A colophon of a Coptic manuscript dated to 1091 (AM 807) shows that the monastery was functioning in the eleventh century. The painter Mercurius, a monk of the Monastery of St. Shenute, inscribed his name in the Monastery of St. Pshoi in 1301 (AM 1017). Al-Maqrizi (d. 1441) mentions the two names of the monastery: "Red Monastery also called monastery of Abu Bishai". In 1672 Johann Wansleben visited the monastery and found it ruined, apart from the church. In about 1798 the Mamluks set fire to the monastery.

Unlike the Monastery of St. Shenute, the Red Monastery is nowadays surrounded by the houses of the village. At the beginning of the last century remains of the monastery's enclosure wall were still visible. Today they are almost completely destroyed, and only the church and the tower keep can be seen. Many modern buildings occupy the area to the southwest and the east of the church. A part of the monastery's buildings is still uncovered. The church of the monastery dates from the second half of the fifth century; the columns in the nave and the surrounding walls are probably a little younger, belonging to the sixth century. The church is much smaller than that of the White Monastery, but the plan and the architec-

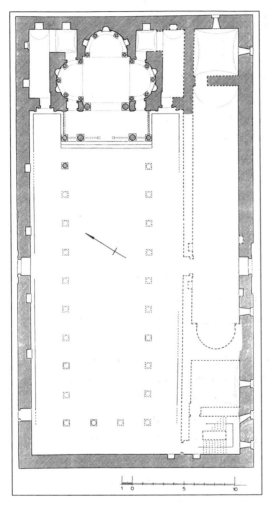

Church of the Monastery of St. Pshoi

tural treatment are similar. The structure was originally of basilican type with two side aisles and a western return aisle. Like most monastic churches it has no narthex. There were several side rooms in the southern part of the church, but almost no traces of them remain. Two gamma-shaped side rooms flank the *triconch* sanctuary. The tower was built in front of the gate in the south wall, through which the church is entered. The tower can be dated to the ninth century.

The church's most interesting feature is the architectural sculpture of its *triconch* sanctuary. But the decoration in its medieval outer walls contains reused sculptured stone pieces that have been inserted into the later brick walls. Some of them were put up with no regard for harmony, as for example in the two entrances, the north door and the south door of the outer walls, where the lintels show unintelligibly superimposed decorative patterns. (see plate 9.2) However, the attractive architectural decoration of the *triconch* sanctuary from the second half of the fifth century is uniquely preserved. Its walls are adorned with columns in two rows and between the columns are niches. (see plate 9.3) Those of the lower row feature broken gables with rec-

tangular central sections. Two pilasters, decorated with foliate motifs support the gable. The niches of the upper rows show further development; the broken pediment is separated from the head niche, which has a semicircular outline. Some of the pediments are decorated with a cross. Unlike the splendid church of the Monastery of St. Shenute, the architectural decoration of this church was achieved with considerable economy. Several parts of the building, such as the pilaster shafts of many niches, are decorated with paintings instead of sculpture. Almost all the column capitals are in the Corinthian style. (see plate 9.4) The paintings in the sanctuary and in the gamma-shaped side room to the north of the sanctuary suffered much and were partly destroyed. Some of them, which cannot be seen today, were copied in the early twentieth century. (see plate 9.5) The painting of the central semidome of the sanctuary is considerably damaged. A scene of the Crucifixion flanked by two figures can be traced. The northern semidome shows a representation of three large arches, which are supported in the middle by two pillars. The two side arches are taller than the central arch and each contains two figures, presumably saints. Above them there are other, smaller arches. Over the doorway that leads from the sanctuary to the northern side room a painting depicts Apa Theophilus holding a book in the left hand and raising the right in blessing. (see plate 9.6) The dome of this room is decorated with four angels, with four medallions containing the busts of the four Evangelists between them. The south wall shows Christ standing flanked by two worshipping angels. His head is set within a crossed nimbus. He carries a book in his left hand and his right is raised in benediction. The southern semidome is decorated with a representation of the enthroned Christ again holding a book in his left hand and blessing with the right; a crossed nimbus surrounds his head. He is flanked by two arches, under which are two sitting saints. Four columns support three arches, each column is decorated by a saint. Behind the figure of Christ, which has been repainted or "restored" by a second painter, there is an arch. A column and an arch with depictions of saints are represented on each side of Christ. The arches are adorned with crosses and lamps. Some of the columns of the two lower rows still preserve painted decorations.

Many of the niches show a figure that represents an apostle or a saint. It has been suggested that the style of some paintings (for example, that of Apa Theophilus) dates to the seventh or eighth century. The representation of Christ flanked by two angels on the northern side room of the sanctuary may be the work of the painter Mercurius, who inscribed his name there in 1301 (AM 1017), and who was perhaps responsible for repainting the figures in the niches. Recent investigations in the church of the Monastery of St. Pshoi have revealed six superimposed layers of paintings and discovered new paintings. One of them is a cross on the wall which separates the nave from the sanctuary, above the entrance to the northern room. The subject of another scene, found in the sanctuary, can be identified as Moses receiving the tablets of the Law and the Burning Bush. The ongoing project to document, conserve, and study the wall paintings in the church of the Monastery of St. Pshoi will undoubtedly provide additional information about them. The church's architectural sculpture is very significant because it represents one of the very few complexes of such decoration in Egypt which dates with certainty from the fifth century. After the completion of its wall paintings this monastery will be one of the most beautiful in the world.

Bibliography

Badawy 1978, pp. 73, 76, 182, 272; Coquin and Martin 1991d; Gabra in press; Grossmann, 1982, p. 125; idem 1991k; idem 1998, pp. 234–236; Innemée, in press; Meinardus 1769–1970; idem 1976; idem 1981; Severin 1991c; idem 1998, pp. 314–317; Timbie 1998, pp. 430–436; Timm II, pp. 639–642; Walters 1974, p. 310f.

The Monasteries
of Aswan

According to literary sources churches existed in the neighborhood of Aswan as early as the third century. Shortly after 325, Aswan became the residence of a bishop, to whose episcopate the island of Elephantine also belonged. A bishop of Philae is mentioned in 362. Only the ruins of a few ancient churches, consisting of the foundations and some fallen elements such as column shafts, have survived. Two monasteries remain in Aswan. The Monastery of Anba Hatre, also known as the Monastery of St. Simeon, is famous and visited by many tourists. By contrast, the other monastery is little known and attracts few visitors. It is known as Dayr Qubbat al-Hawa, after a sheikh buried on the hill. Recently, interesting wall paintings along with Greek and Coptic inscriptions were discovered at the latter site.

The Monastery at Qubbat al-Hawa

This monastery was established on the hill to the west of Aswan, where the tombs of the nobles of Aswan were hewn during pharaonic times. (see plate 10.1) Different names have been associated with this monastery, but generally on inadequate grounds: it has been called the Monastery of St. George, of St. Laurentius, and of the Savior. It may be the monastery mentioned by the church historian Abu al-Makarim in the early thirteenth century as the Monastery of Antony. However, the

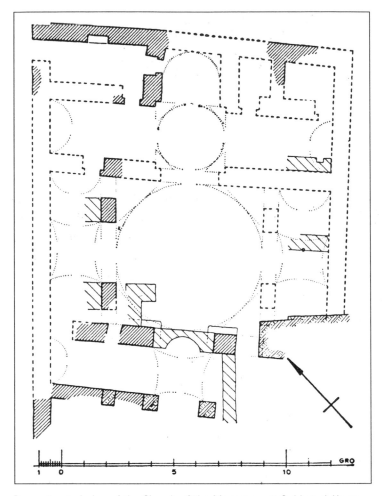

Reconstructed plan of the Church of the Monastery at Qubbat al-Hawa

monastery was probably a dependency of the considerably larger Monastery of Anba Hatre.

The golden age of the monastery at Qubbat al-Hawa was in the Fatimid Period (972–1171), when a large residential building of several stories with a central corridor and sleeping rooms was erected. There are

remains of a church in front of the pharaonic tomb of Khune. It follows the plan of an octagon-domed structure and might have been constructed after the beginning of the Fatimid Period (973) but before the end of the eleventh century. In 1998 debris was removed from the area of the church, revealing beautiful wall paintings and Coptic and Arabic texts. The apse in the west wall of the church features a two-zoned composition, which was popular in monastic painting. (see plate 10.2) In the upper section Christ is represented in a *mandorla*. He holds a book in his left hand and raises the right in blessing. Six angels, depicted in full flight, hold the *mandorla*. (see plate 10.3) In the lower section the Holy Virgin Mary stands in the center flanked by the twelve Apostles. (see plate 10.4) At the north side of the apse there is a long room with a barrel vault. Its west wall shows six standing figures; five of them are depicted with a square *nimbus*, indicating that they were still living at the time the painting was executed. (see plates 10.5 and 10.6) Many Coptic texts appear on the walls. One of them is particularly significant, for it is written on a layer of plaster which was applied over the painting. It bears the date AM 896 (1180 CE), (see plate 10.7) proving that the the wall paintings of the church must have been executed before that time. There are many other Coptic texts as well, preserved under a thin layer of plaster which requires treatment by a skillful conservator. The murals and the texts, both Coptic and Arabic, of this church are very important for the history of Christianity and monasticism at Aswan, which was located at the border to the Christian Kingdom of Nubia. The paintings of the church provide invaluable documentation for the study of Coptic art in the second millennium.

Bibliography

Adams 1991; Coquin and Martin 1991a; idem 1991b; Gabra, in press; Grossmann 1985; idem 1991g; idem 1991h; idem 1991i; Timm I, pp. 222–235, pp. 392–401, III, pp. 1044–1049.

The Monastery of Anba Hatre
(St. Simeon)

The monastery of Anba Hatre (Hidra) **(see plate 11.1)** is situated about one thousand two hundred meters from the west bank of the Nile at a latitude south of the island of Elephantine. Coptic and Arabic sources call this monastery Anba Hatre (Hidra, Hadri), but later it was given the name St. Simeon by archaeologists and travelers. St. Hatre was an anchorite who was consecrated a bishop of Aswan by Patriarch Theophilus (385–412); he died in the time of Emperor Theodosius I

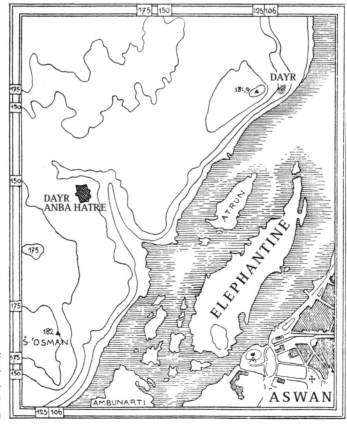

Region of Aswan (after Monneret de Villard 1927 a, fig. 1)

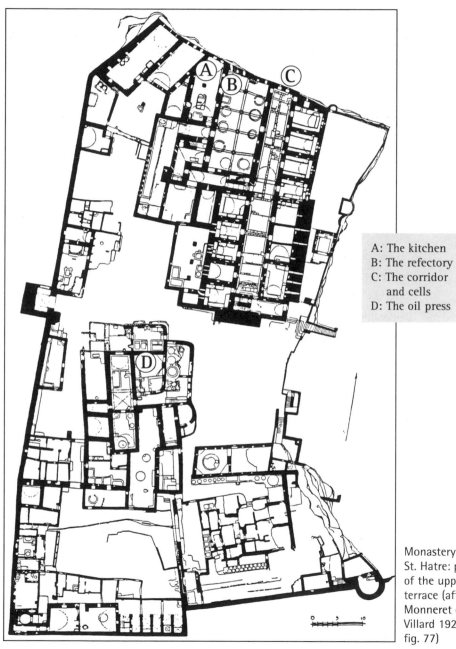

A: The kitchen
B: The refectory
C: The corridor
 and cells
D: The oil press

Monastery of
St. Hatre: plan
of the upper
terrace (after
Monneret de
Villard 1927 a,
fig. 77)

(379–395). It is not known whether a monastic settlement had been established in the region of the hermitage of Anba Hatre as early as that date. However, it is clear that by the sixth or the seventh century there existed a settlement at the site from wall paintings in some of the rock caves dating to that period. The monastery underwent considerable rebuilding, which included tall structures, in the first half of the eleventh century. Abu al-Makarim spoke of the monastery as occupied by monks. By the end of the thirteenth century the monastery had been abandoned.

Although many parts of the monastery of Anba Hatre are ruined, it is of great architectural interest. Its church provides the most important example of the domed oblong church in Egypt. The keep of the monastery, designed to serve as a permanent lodging complex, is the most developed of its kind. A large number of tombstones have been found in the cemetery of the monastery. They are indispensible for the study of Christian tombstones in the Nile Valley. The pottery kilns of the monastery are also significant for research on the pottery of Aswan.

A cliff divides the monastery into two natural terraces on two levels. The terraces are enclosed within a relatively thin trapezoid wall with a parapet. Each terrace has its own gate. The lower terrace comprises the original rock caves of the saints, the church with the baptistery, and many rooms for pilgrims. The upper terrace is designed as a large keep providing permanent living quarters for the community. There are cells for the monks, a refectory, a kitchen, and several workshops. No cistern or well which could have had secured the water supply during long sieges has yet been discovered inside the complex.

The entrance gateway of the lower level projects from the east wall of the enclosure. Its vestibule, which leads into the monastery, is barrel vaulted; the east wall of the church faces visitors as they enter the monastery. The church (see plates 11.2 and 11.3) was constructed in the first half of the eleventh century. Even though only its lower part has been preserved, the church is of considerable interest for its architecture. It represents the most significant example of a domed oblong church, a

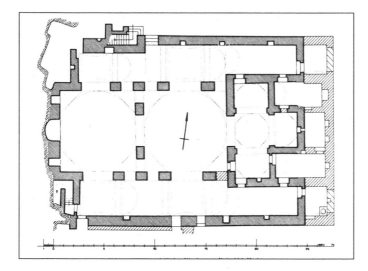

Church of
the Monastery
of St. Hatre

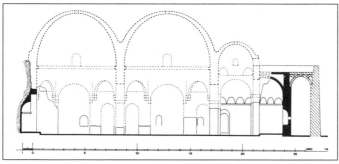

Projected
elevation
of the Church
of the
Monastery
of St. Hatre

type which is known in Egypt beginning in the Fatimid Period. At the same time it is of the octagon-domed type, with two domed bays provided for the nave. The rectangular sanctuary was originally connected with the *khurus* so that together they formed a large single trefoil with three rectangular compartments. It is one of the oldest and at the same time the most significant of its kind in Egypt. The eastern zone of the church was enlarged by the addition of two rectangular rooms, covered with half domes, that flank the sanctuary. The room behind the sanctuary is reminiscent of the corridor behind the sanctuary in Nubian churches. Both aisles end to the east along the sanctuary in a room which originally had

an entrance in its east wall. This arrangement is unusual in Coptic churches and the entrances were subsequently blocked. The room at the east end of the south aisle served as a baptistery.

A number of wall paintings of the Monastery of Anba Hatre could still be seen in the late nineteenth century. Unfortunately a considerable portion of them are now badly damaged or have been destroyed. The eastern semidome of the sanctuary is decorated with a scene of Christ enthroned within the *mandorla* with flames licking at its base. The *mandorla* is held by two angels. On the extreme right a person with a square nimbus appears in an *orans* position. Christ holds a book on one knee with his left hand. His right hand, which extends beyond the edge of the *mandorla*, is raised in blessing. (see plate 11.4) The decoration below the scenes features arcades and pendentives. On the north wall of the sanctuary there are the remains of a painting of juxtaposed, haloed figures seated, representing the Twenty-four Priests. (see plate 11.5) The painting in the niche on the west side of the church shows the Holy Virgin Mary standing between two bowing angels. It has been suggested that the wall paintings of the church were executed in the eleventh or twelfth century. However, there is more than one layer of painting in the apse of the church.

A grotto at the west end of the north aisle of the church is an ancient Egyptian rock tomb that was used by monks as a habitation. Its three walls were originally decorated with a sequence of figures numbering thirty-six in one register. (see plate 11.6) They could represent some of the seventy-two disciples of Christ. The ceiling of the grotto features busts within large squares and small octagons, which are set against the geometrical design of a fretwork pattern. (see plate 11.7) The paintings of the grotto can be dated to the sixth or the seventh century.

The upper terrace, which was also designed to serve as a keep, is approached by a stairway along the north wall of the church. The keep is a huge three-storied building dominating the monastery. (see plate 11.8) Its massive size is unusual in comparision to the keeps of other monasteries. With its cells, refectory, kitchen, and other facilities, the

keep represents the climax of the development of the keep-like lodging complex in Egypt. On the ground floor there is a refectory and rows of cells flank a vaulted corridor. The corridor is oriented north-south, and the wall at its north end is the northern enclosure wall of the monastery. Three windows furnish the corridor with light. (see plate 11.9) Most of the cells are furnished with a number of stone beds, sometimes six or more. (see plate 11.10) On the northwest side of the corridor there is a refectory. It is a rectangular room, which was originally divided by a row of four columns and roofed by two rows of contiguous cupolas on pendentives. The floor is paved with baked bricks and on it seven mud brick rings can be traced. These rings indicate the placement of seats used by monks when they took their common meals. (see plate 11.11) It is worth noting that, according to the evidence of the oldest refectories, the monks sat in groups, arranged in a circle, and not at long tables. To the west of the refectory lies the kitchen with its dependencies. One of the rooms contained a reservoir forming a part of the water supply system. Although no well was found within the monastery's enclosure, the elaborate plumbing arrangements show that the water available on the upper terrace also supplied bathrooms, latrines, and several laundering establishments. The mill and the bakery are outside the keep; a number of ovens of different sizes were found on both terraces. The pottery kilns at the south zone of the monastery are of special interest for the study of the pottery of Aswan, which was used in Upper Egypt and in Nubia during Roman, Byzantine, and early Islamic times. The oil press is situated on the upper terrace south of the keep. The millstone of the oil press was made of granite and decorated with three crosses. (see plate 11.12) The cemetery of the monastery yielded nearly two hundered tombstones; a considerable number of them range in date from the sixth to the ninth century. They provide valuable material for the study of Christian tombstones in Egypt and in Nubia, especially concerning the development of the Coptic texts, which show three distinct editions and different prayer formulas.

Bibliography

Ballet et al. 1991, p. 141f.; Descœudres 1998, p. 76, fig. 5; Gabra 1988; Grossmann 1982, pp. 7–13; idem 1991d; Krause 1975, esp. pp. 77, 79; de Morgan et al. 1894, pp. 129–141; Monneret de Villard 1927; idem 1927a; Timm II, pp. 664–667; Walters 1974, pp. 93–97, 311–313.

Ruined Monasteries

During the early centuries of monasticism the Egyptian desert witnessed a rapid increase in the number of monasteries and monks. St. Jerome (ca. 347–419/420) spoke of fifty thousand Pachomian monks. Relying upon ancient historians, al-Maqrizi (d. 1441) stated that seventy thousand monks from Scetis went to meet general 'Amr ibn al-As at the time of the Arab conquest of Egypt. Even if these figures are exaggerated and untrustworthy, they nevertheless indicate that the number of monks was extremely large. Many monasteries are mentioned in different texts. Most of them were abandoned and subsequently disappeared, or their ruins have not yet been discovered. Unfortunately it is impossible to identify the sites of several monasteries which played a crucial role in the history and culture of the Coptic Church in different periods.

From 705 on, monks were obliged to pay the poll tax, and in 715 monks were even branded. The financial burdens imposed on the monks and the confiscation of church property led to the gradual impoverishment of these prosperous ancient Coptic institutions. It is not surprising that monasticism was thereby greatly diminished. In 1088 there were only 712 monks divided among four monasteries at the great monastic center of Wadi al-Natrun. Little by little many monasteries were abandoned and the cells, as well as the common buildings, filled with sand. The monastic complexes, which were deserted between the ninth or tenth and the twelfth centuries, provide the greater part and perhaps the

most important and beautiful monastic paintings and architectural sculptures—the monasteries of St. Jeremiah at Saqqara, of St. Apollo at Bawit, and of St. Bane or Abu Fana at Minya, and the monastic settlement of Kellia.

The monuments of the monasteries of St. Apollo at Bawit and of St. Jeremiah at Saqqara were discovered in the first two decades of the twentieth century. Sculptures and paintings from these two monasteries occupy a considerable part of the ground floor of the Coptic Museum's New Wing. They have been the subject of research and study during the last thirty years. It has been fairly well established that many of the sculptures used in the monasteries at Bawit and Saqqara were brought there from other buildings. One suggestion proposes that these old buildings once belonged to wealthy families of Greek origin who left Egypt following the Arab conquest of the country, leaving craftsmen and artisans behind to continue the old sculptural traditions. It is difficult to confirm or disprove this theory given the lack of a new comprehensive study of Coptic art, but it may be noted that in the few centuries before the Arab conquest the number of hellenized Egyptians grew and gradually many "Greek" or "Roman" citizens lost their special status due to deteriorating economic conditions.

The Monastery of St. Apollo at Bawit

The archaeological site of Bawit is located on the west bank of the Nile about three hundred and twenty kilometers south of Cairo between al-Ashmunein (Hermopolis) and Dayr al-Moharraq. In the last decade of the nineteenth century and at the beginning of the twentieth century the site suffered illegal digging and was known to dealers in antiquities as a source of monuments and beautiful artifacts. Between 1901 and 1904 and again in 1913 soundings and limited systematic excavations were undertaken at the famous site of Bawit. Only a small part of the site was

cleared and two main constructions were described by the excavators as the North Church and the South Church. Several small buildings are scattered over the site; some of them represent regular building complexes. The monastery of Bawit consisted of many small monasteries with cells and a little church, all protected by an enclosure. At the end of the excavations the architectural sculpture and a selection of relatively well-preserved wall paintings were removed from the site. The majority of the architectural carvings were thus separated from their original setting. There are five monasteries in Egypt named after St. Apollo. Therefore it is difficult to assign the majority of the documents, which have found their way to many collections through antiquities dealers, to a particular monastery of that name. A number of sale contracts from the ninth century are important for the study of the organization of the Monastery of St. Apollo in Bawit at that time. They provide evidence for the sale of cells in order to raise funds to pay the poll tax, which was imposed on the monks beginning in 705.

It has been generally accepted that the large monastic community in Bawit was governed by St. Apollo, who was mentioned in the *Historia monachorum in Aegypto* as being more than eighty years old around 395. The Monastery of St. Apollo at Bawit flourished in the sixth and seventh centuries and it continued to be prosperous as late as the ninth century. It is not known when the monastery was abandoned. However, the church historian Abu al-Makarim did not mention the monastery.

The monuments of the Monastery of St. Apollo, and especially the architectural sculptures, need further study. It has been suggested that the original building of the South Church is a non-Christian structure dating from the fourth century, but it has not yet been possible to determine its original function. Parts of the North Church derive from an older construction. In a later phase, in the eighth century, pre-existing components were supplemented with mudbrick walls, and reused bases and columns were added. In 1976 excavations were again carried out at Bawit, which yielded beautiful murals. Unfortunately no report is avail-

able on the circumstances of their dicovery. Very recently (1999) French scholars published a volume on the monastery and the necropolis of Bawit, based on old reports, which considerably increases our information about the sculptures, wall paintings, pottery, papyri, and *ostraca* associated with the site. The archaeological remains at Bawit must be systematically examined through scientific excavations.

The monuments of the Monastery of St. Apollo are widely scattered; in Europe there are objects in the Louvre in Paris and in the Museum of Late Antique and Byzantine Art of Berlin. The Coptic Museum in Cairo possesses a large collection of stone and wooden sculptures as well as wall paintings from Bawit. The greater part of the collection is situated in the lower floor of the New Wing (Halls 3 and 4). There follows an introduction to some of these beautiful monuments.

This composite capital (see plate 12.1) was discovered in the North Church. It measures 65 cm in height and is 107 cm in width and length at the top. The diameter of its base is 64 cm. The capital dates from the sixth century. Its base resembles a shallow basket decorated with quatrefoils, rosettes, and meandering patterns. From the base spring stylized acanthus branches, which are arranged in the lower part in sets of three branches with drooping tips. The other branches are long and thin. The green background enhances the charm of this most beautifully sculpted capital.

Different types of frieze ornaments came from Bawit. They are richly decorated and stylistically varied. Of special interest are the foliate patterns and geometric designs. (see plate 12.2) The upper frieze is decorated with elaborate interlaced acanthus foliage. The lower frieze shows a series of circles forming a sequence of quatrefoils which are occupied by foliate ornaments. The friezes can be attributed to the fifth or the sixth century.

The paintings in the niches of the oratories of Bawit usually depict the Virgin and Child and Christ in Majesty. This sixth/seventh century niche (see plate 12.3) is one of the masterpieces of the Coptic Museum (220 cm x 170 cm). In its upper zone Christ is depicted enthroned in a *mandorla* carried on wheels with flames licking at its base. Four wings

protrude from the sides of the *mandorla*. They incorporate the four apocalyptic creatures, the bearers of God's throne: eagle, ox, lion, and man. The Archangel Michael stands to the left, Gabriel to the right. In the lower zone the Virgin is enthroned, holding the infant Jesus on her lap and surrounded by the twelve Apostles and two local saints. Jesus carries a scroll in his left hand. The Virgin wears a long robe which also covers her head. The apostles and the two local saints stand and hold books; Peter holds a key in his left hand while Paul grasps a staff surmounted by a cross in his right hand. They are schematically painted except for their hair and beards. All the figures are haloed. The simple material of mud and plaster and the bright colors contribute to the attractiveness of this niche.

In 1976 a remarkable portrayal of Christ the Savior was discovered in the Monastery of St. Apollo at Bawit. (see plates 12.4 and 12.5) The painting, in tempera technique, shows Christ's figure as a bust within a floral garland carried by two winged angels who appear in flight. The elaborately executed head of Christ is set against a jewelled cross. The face narrows sharply towards the chin, the beard is short, and the mouth is relatively small below a drooping moustache. The hair falls over the shoulders. The eyes are wide with thick eyebrows. This sixth/seventh century painting represents one of the most beautiful portrayals of Christ in Coptic art.

Bibliography

Bénazeth 1996; idem 1997; idem 1998; du Bourguet 1991; Clédat 1999; Gabra 1993, pp. 58 f., 61, 94; Krause 1998, pp. 161, 166f.; Krause and Wessel 1966; Rassart-Debergh 1981, pp. 251–255; Rutschowscaya 1995; Severin 1977; idem 1991; idem 1998, pp. 300 f., 336; Timm III, pp. 643–653; Walters 1974, pp. 251–292.

The Monastery of St. Jeremiah at Saqqara

The Monastery of St. Jeremiah is situated at Saqqara, the famous necropolis of ancient Memphis. **(see plate 13.1)** The causeway of the pyramid of Unas demarcates its northern extent. In the history of John of Nikou (seventh century) Jeremiah is mentioned as a contemporary of Anastasius, emperor from 491 to 518. The excavator of the monastery dated its foundation to about 470, but archaeological evidence does not support this dating as none of the remains are older than the middle of the sixth century. However, monasticism was established in the environs of Memphis at the end of the fourth or early fifth century. The monastery flourished during the seventh and the eighth centuries. Occupation probably ceased around the middle of the ninth century.

The Monastery of St. Jeremiah is one of the few monasteries of cenobitic monks which have been archaeologically examined. Since their discovery in the first decade of the last century the monuments of this monastery have become an indispensible source for the study of Coptic art. Archaeological activity which took place at the site of the monastery in the 1970s and 1980s represents a significant step towards a new evaluation of Coptic architectural sculpture.

The main church was the central element in the monastery. It was originally a small, simple chapel that was constructed in the second half of the sixth century as a columned basilica with a narthex. Around the middle of the seventh century the church was considerably enlarged. It has been suggested that the greater part of the architectural sculptures of this church, including the columns, were derived from demolished late Roman sepulchral buildings, presumably mausoleums. The sculptures date mainly from the fifth century and the first half of the sixth century. The cells of the monks are arranged around the main church. Building no. 1823, described by the excavator as a tomb church, proved to be the upper part of a late fourth or early fifth century non-Christian tomb. Appparently it

is the only structure which was built with original sculpture. The so-called South Church was more probably an atrium. The monastery included refectories, kitchens, an oil press, facilities for baking bread, store rooms, and workshops, as well as other rooms the function of which is still obscure. The reuse of stones with Coptic inscriptions is responsible for the incorrect identification of some buildings. A section of the monastery was reserved for nuns. The titles of the monastery's functionaries, which are preserved on the tombstones, provide valuable material for the history of the monastery.

The majority of the sculptures, the tombstones, and the paintings that have been preserved were removed to the Coptic Museum. A small collection of sculpture is in the British Museum. A considerable portion of the sculptures and a number of the painted niches

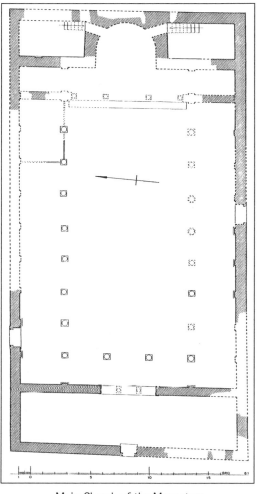

Main Church of the Monastery
of St. Jeremiah at Saqqara

are exhibited in the Saqqara hall (no. 6) of the Coptic Museum. The following paragraphs present some of these remarkable monuments.

This elegant sixth-century capital is one of the most beautifully sculptured capitals of the Monastery of St. Jeremiah. (see plate 13.2) The acanthus branches are twisted as if by a violent wind. It is the only cap-

ital from the Nile Valley of the wind-blown acanthus leaf design. The capital more closely resembles a similar piece in St. Demetrius and St. Sophia at Saloniki than the nearest local imitation, which is in the Monastery of St. Catherine on Mount Sinai. The capital was executed for a Christian building and cannot be attributed to a non-Christian tomb as the top of its design incorporates a cross within a wreath.

The basket capitals from Saqqara date mostly from the middle of the sixth century. The majority of scholars reject the suggestion that they were an Egyptian invention. They derive instead from capitals of the time of Justinian at Ravenna and Constantinople. This basket-shaped capital is of outstanding beauty. (see plate 13.3) It is 33 centimeters high, 40 centimeters in width and length, and 21 centimeters in diamter at its base. Its decoration features the convex profile of a vase with eight flanges, deeply carved with vine leaves and bunches of grapes. The colors of the fanciful interlaced stems and leaves result in an interplay of light and shadow. A remarkable sixth century frieze (see plate 13.4) shows a cross in the center and scrolls consisting of acanthus branches, forming circles with offshoots inhabitated by animals—a lion and a gazelle—on the sides of the cross. The two scrolls at the extreme left and right are occupied by a bust.

In the Monastery of St. Jeremiah many saints are depicted, but only a few of them are identified by accompanying inscriptions. An exception is represented by part of a longer scene, from which remain four saints and a crouching penitent. (see plate 13.5) The arrangement of the saints alternates an *orans* with a standing figure holding a book with both hands. All the saints are haloed. The saint to the left is naked. His long hair hangs down on both sides of his body to his ankles. According to the excavator there was a palm tree to his right and its presence identifies the saint as Onnophrius. The second saint is Macarius, "the bearer of the spirit." He wears a *tunica* and there is a pallium draped over his left arm. The next figure is Apa Apollo the Great. Over the *tunica* he wears a mantle thrown back over his shoulders and hanging down on

both sides of his body. Two crosses, along with the upper part of their supporting staffs, can be seen behind his shoulders. The first saint to the right is Pamun. The eyes of the four saints are rimmed by dark shading. The chin is rendered as a circle or as a dark spot. Though the features are conventionalized, individuality is manifested in the coiffure and the beard type. The scene dates to the seventh century.

Bibliography
Gabra 1993, pp. 62–65; Grossmann 1991e; Grossmann and Severin 1982; Krause 1994, pp. 28–31; idem 1998, p. 162 f.; van Moorsel and Huijbers 1981; Quibell 1908; idem 1909; idem 1912; Rassart-Debergh 1981a–c; idem 1991, idem 1991a; Severin 1991a; idem 1998, pp. 301 f., 333 f.; Wietheger 1992.

Bibliography

Abbreviations

BIFAO: Bulletin de l'Institut Français d'Archéologie Orientale, Cairo.

BSAC: Bulletin de la Société d'Archéologie Copte, Cairo.

CE: Aziz S. Atiya (ed.), The Coptic Encyclopedia, 8 volumes, New York 1991.

ICCoptS 4: Marguerite Rassart-Debergh and Julien Ries (eds.), Actes du IVe congrès copte. Louvain-la-Neuve, 5-10 Septembre 1988, 2 vols. (Publications de l'Institut Orientaliste de Louvain 40–41), Louvain-la-Neuve 1992.

Les Kellia: Les Kellia, ermitages coptes en Basse-Egypte, exhibition, Musée d'art et d'histoire, Genève, October 12, 1989–January 7, 1990, Geneva 1989.

MDAIK: Mitteilungen des Deutschen Archäologischen Instituts, Abteilung Kairo, Mainz.

MIFAO: Mémoires publiès par le membres de l'Institut Français d'Archéologie Orientale, Cairo.

SKCO 3: Martin Krause and Sofia Schaten (eds.), ΘΕΜΕΛΙΑ. Spätantike und koptische Studien. Peter Grossmann zum 65. Geburtstag (= Sprachen und Kulturen des Christlichen Orients 3), Wiesbaden 1998.

SKCO 4: Martin Krause (ed.), Ägypten in spätantik-christlicher Zeit. Einführung in die koptische Kultur (= Sprachen und Kulturen des Christlichen Orients 4), Wiesbaden 1998.

SKCO 6: Stephen Emmel, Martin Krause, Siegfried Richter und Sofia Schaten (eds.), Ägypten und Nubien in spätantiker und christlicher Zeit: Akten des 6. Internationalen Koptologenkongresses, Münster 20.–26. Juli 1996, 2 vols. (= Sprachen und Kulturen des Christlichen Orients 6), Wiesbaden 1999.

Timm: Stefan Timm, Das christlich-koptische Ägypten in arabischer Zeit, 6 volumes (= Beihefte zum Tübinger Atlas des vorderen Orients, Reihe B (Geisteswissenschaften), n. 41/1-6) Wiesbaden 1984–1992.

Abbott, Nabia. 1937. *The Monasteries of the Faiyum*. Chicago.

Adams, William Y. 1991. "Philae: Physical Characteristics." CE 6. p. 1954 f.

Agpia: The Prayer Book of the Seven Canonical Hours. 1997. Sydney.

Akermann, Philippe. 1977. *Le décor sculpté du Couvent blanc: niches et frises*. Bibliothèque d'études coptes 14: Cairo.

Alcock, Antony. 1991. "Samuel of Qalamun." CE 7. pp. 2092–2093.

Alcock, Antony. 1993. "The Egyptian Church and its Rituals" in Gabra, 1993. pp. 27–29.

Badawy, Alexander. 1978. *Coptic Art and Archaeology. The Art of the Christian Egyptians from the Late Antique to the Middle Ages*. Cambridge, Mass.

Ballet, Pascale, Fatma Mahmoud, M. Vichy, and M. Picon. 1991. "Artisanat de la céramique dans l'Égypte romaine tardive et byzantine. Prospections d'ateliers de potiers de Minia à Assouan." *Cahiers de la céramique égyptienne* 2. Cairo. pp. 129–144.

Bénazeth, Dominique. 1996. "Histoire des fouilles de Baouît, Études Coptes IV" *Cahiers de la bibliothèque copte* 8. Paris-Louvain. pp. 53–62.

Bénazeth, Dominique. 1997. "Un monastère dispersé. Les antiquités de Baouit conservées dans Musées d'Égypte." BIFAO 97. pp. 43–66.

Bénazeth, Dominique. 1998. "Les avatars d'une monument copte: l'église sud de Baouit." SKCO 3. pp. 33–39.

Bolman, Elizabeth. In Press. *Monastic Visions: Wall Paintings from the Monastery of St. Antony at the Red Sea*.

du Bourguet, Pierre. 1991. "Bawit: Paintings." CE. pp. 367–372.

du Bourguet, Pierre. 1991a. "Copt." CE 2. pp. 599–600.

Brashear, Wm. 1998. "Syriaca." *Archiv für Papyrusforschung* 44/1. pp. 86–127.

Brown, S. Kent. 1981. "Microfilming." *Bulletin d'Arabe Chrétien* 5. pp. 79–86.

Burmester, O.H.E. Khs. 1954. *A Guide to the Monasteries of Wadi 'n-Natrun*. Cairo.

Chitty, Derwas J. 1966. *The Desert City*. Chrestwood, Oxford.

Clédat, Jean. 1999. *Le monastère et la nécropole de Baouit*. Notes mises en œuvre et éditées par Dominique Bénazeth et Marie-Hélène Rutschowscaya. MIFAO 111.

Cody, Alfred. 1991. "Dayr al-Baramus: History." CE 3. pp. 789–791.

Cody, Alfred. 1991a. "Scetis." CE 7. pp. 2102–2106.

Cody, Alfred. 1991b. "Dayr Anba Bishoi: History." CE 3. p. 734 f.

Cody, Alfred. 1991c. "Dayr al-Suryan: History." CE 3. pp. 876–879. *The Coptic Liturgy of St. Basil*. 1993. Cairo.

Coquin, René-Georges. 1975. "Livre de la consécration du sanctuaire de Benjamin." *Bibliothèque d'Études Coptes* 13. Cairo.

Coquin, René-Georges. 1991. "Pshoi of Scetis." CE 6. p. 2029 f.

Coquin, René-Georges. 1991a. "Monasteries of the Faiyum." CE 5. p. 1650 f.

Coquin, René-Georges. 1991b. "Monasteries of the Middle Sa'id." CE 5. p. 1654 f.

Coquin, René-Georges and Laferrière, Pierre-Henry. 1978. "Les inscriptions pariétales de l'ancienne église du monastère de S. Antoine, dans le désert oriental." BIFAO. 78. pp. 267–321.

Coquin, René-Georges and Martin Maurice. 1991. "Dayr Anba Bula: Historical Landmarks." CE 3. p. 742.

Coquin, René-Georges and Martin Maurice. 1991a. "Philae: Monasticism." CE 6. p. 1955 f.

Coquin, René-Georges and Martin Maurice. 1991b. "Dayr Qubbat al-Hawa: History." CE 3. p. 850 f.

Coquin, René-Georges and Martin Maurice. 1991c. "Dayr Anba Shinudah: History." CE 3. pp. 761–766.

Coquin, René-Georges and Martin Maurice. 1991d. "Dayr Anba Bishoi: History." CE 3. pp. 736–739.

Dadoyan, Seta B. 1996. "The Phenomenon of the Fatimid Armenians." Medieval Encounters 2/3. pp. 193–213.

Daly, Robert S. 1990. "Origen." Everett Ferguson (ed.) Encyclopedia of Early Christianity. New York & London. p. 668.

Depuydt, Leo. 1993. Catalogue of Coptic Manuscripts in the Pierpont Morigan Library. Leuven.

Descœudres, Georges. "L'architecture des ermitages et les sanctuaires." Les Kellia. pp. 33–55.

Descœudres, Georges. 1998. "Wohntürme in Klöstern und Ermitagen Ägyptens." SKCO 3. pp. 69–79.

Dobrowolski, Jaroslaw. 1990. "Naqlun-deir Al-Malak Ghubra'il: The Existing Monastic Complex." Piotr O. Scholz, C. Detlef, and G. Müller (eds.) Nubica I/II, International Annual for Ethiopian, Meroitic and Nubian Studies. Köln. pp. 161–170.

Elm, Susanna. 1994. Virgins of God: The Making of Asceticism in Late Antiquity. Oxford.

Emmel, Stephen. 1999. "Editing Shenute: Problems and Prospects." SKCO 6/2. pp. 109–113.

Evelyn-White, Hugh G. 1926. The Monasteries of Wadi'n Natrun, Part I: New Coptic Texts from the Monastery of St. Macarius. New York.

Evelyn-White, Hugh G. 1932. The Monasteries of Wadi'n Natrun, Part II: The History of the Monasteries of Nitria and of Scetis. New York.

Evelyn-White, Hugh G. 1933. The Monasteries of Wadi'n Natrun, Part III: The Architecture and Archaeology. New York.

Evetts, B.T.A. (ed.). 1895. *The Churches and Monasteries of Egypt and Some Neighbouring Countries, Attributed to Abû Sâlih, the Armenian*. Oxford.

Frend, W.H.C. 1972. *The Rise of the Monophysite Movement*. Cambridge.

Gabra, Gawdat. 1988. "Hatre (Hidra)." *Heiliger und Bischof von Aswan im 4. Jahrhundert*. MDAIK 44. pp. 91–94.

Gabra, Gawdat. 1993. *Cairo: The Coptic Museum & Old Churches*. Cairo.

Gabra, Gawdat. 1997. "Dayr Anba Musa al-Aswad: Das originale Baramus-Kloster im Wadi al-Natrun." BSAC 36. pp. 71–74.

Gabra, Gawdat. 1997. "Die Weihung eines Sanktuars (Haikal) des Erzengels Gabriel." BSAC 36. pp. 75–81.

Gabra, Gawdat. In press. "'New' Discoveries of Coptic Monuments: Problems of their Preservation and Publication." *Acts of the Seventh International Congress of Coptic Studies, Leiden, August 27– September 2, 2000*.

Gabra, Gawdat. In press(a). "The History of the Monastery of St. Antony: Thirteenth–Twentieth Century." Bolman.

Garitte, Gérad (ed.). 1943. "Panégyrique de saint Antoine par Jean, évêque d'Hermopolis." *Orientalia Christiana Periodica* 9/3. pp. 100–134 & pp. 330–365.

Godlewski, Wlodzimiers. 1993. "Naqlun 1989–1992." David W. Johnson (ed.) *Acts of the fifth International Congress of Coptic studies, Washington, 12–15 August. 1992*. 2/2. pp. 183–195.

Godlewski, Wlodzimiers. 1997. "Deir el Naqlun. Topography and Tentative History." *Archeologia e papiri nel Faiyum. Storia della ricerca, problemi e prospettive, atti del convegno internazionale*. Siracusa. 42–25. Maggio. pp. 123–145.

Godlewski, Wlodzimiers. 1999. "Naqlun 1993–1996." SKCO 6/1. pp. 157–161.

Godlewski, Wlodzimiers, Tomasz Derda, and Tomasz Gorecki,. 1994. "Deir el Nanqlun (Nekloni), 1988–1989, Second Preliminary Report." Piotr Scholz (ed.) *Nubica III/1, International Journal for Coptic, Meroitic, Nubian, Ethiopian, and Related Studies*. Warsaw. pp. 201–263.

Grossmann, Peter. 1982. "Mittelalterliche Langhauskuppelkirchen und verwandte Typen in Oberägypten." *Abhandlungen des deutschen archäologischen Instituts Kairo, Koptische Reihe*. 3. Glückstadt.

Grossmann, Peter. 1985. "Ein neuer Achtstützenbau im Raum von Aswan in Oberägypten." *Mélanges Gamal Eddin Mokhtar*. Bd'E. 97/1. Cairo. pp. 339–348.

Grossmann, Peter. 1985a. "New Observations in the Church and Sanctuary of Dayr Anba Šinuda – the So-Called White Monastery- at Suhag." *Annales de Service des Antiquités de l'Égypte*. 70. 1984 / 1985. pp. 69–73.

Grossmann, Peter. 1991. "Dayr al-Baramus: Architecture." CE 3. pp. 791–793.

Grossmann, Peter. 1991a. "Dayr Anba Bishoi: Architecture." CE 3. pp. 735 f.

Grossmann, Peter. 1991b. "Dayr al-Suryan: Architecture." CE 3. pp. 879–881.

Grossmann, Peter. 1991c. "Dayr Anba Antuniyus: General Layout of the Monastery." CE 3. pp. 723–726.

Grossmann, Peter. 1991d. "Dayr Anba Hadra: Architecture." CE 3. pp. 745–746.

Grossmann, Peter. 1991e. "Dayr Apa Jeremiah: Archaeology." CE 3. pp. 773–776.

Grossmann, Peter. 1991f. "Dayr al-Naqlun: Architecture." CE 3. pp. 845–847.

Grossmann, Peter. 1991g. "Aswan." CE 1. pp. 294–296.

Grossmann, Peter. 1991h. "Elephantine." CE 3. pp. 951 f.

Grossmann, Peter. 1991i. "Dayr Qubbat al-Hawa: Monuments." CE 3. pp. 851f.

Grossmann, Peter. 1991j. "Dayr Anba Shinudah: Architecture." CE 3. pp. 766–769.

Grossmann, Peter. 1991k. "Dayr Anba Bishoi: Buildings." CE 3. pp. 740.

Grossmann, Peter. 1995. "L'architecture de l'église de St.-Antoine." van Moorsel. 1995b. pp. 1–19.

Grossmann, Peter. 1996. "Kirchenbau in Ägypten." *Ägypten. Schätze aus dem Wüstensand. Katalog der Ausstellung Gustav-Lübcke-Museum Hamm.* Wiesbaden. pp. 43–57.

Grossmann, Peter. 1997. "Zur Datierung der ersten Kirchenbauten in der Sketis." *Byzantinische Zeitschrift* 90. pp. 367–395.

Grossmann, Peter. 1998. "Koptische Architektur." SKCO 4. pp. 209–267.

Grossmann, Peter. 1998a. "Altägyptische Elemente in der frühchristlichen Baukunst Ägyptens" Heike Guksch and Daniel Polz (eds.) *Stationen. Beiträge zur Kulturgeschichte Ägyptens: Rainer Stadelmann Gewidmet.* Mainz. pp. 442–458.

Grossmann, Peter and Hans-Georg Severin. 1982. "Reinigungsarbeiten im Jeremiaskloster von Saqqara IV." MDAIK 38. pp. 155–193.

Grossmann, Peter and Hans-Georg Severin. Zum. 1997. "Antiken Bestand der al-'Adra Kirche des Dayr al-Baramus im Wadi Natrun." *Mitteilungen zur christlichen Archäologi* 3. pp. 30–52.

Guillaumont, Antoine. 1977. *Histoire des moines aux Kellia. Orientalia Lovaniensia Periodica* 8. pp. 187–203.

Guillaumont, Antoine and K.H. Kuhn. 1977. "Histoire des moines aux Kellia." *Orientalia Lovaniensia Periodica* 8. pp. 187–203.

Guillaumont, Antoine and K.H. Kuhn. 1991. "St. Paul of Thebes." CE 6. p. 1925 f.

Hardy, Edward Rochie. 1952. *Christian Egypt, Church and People.* New York.

Hewison, R. Neil. 1986. *The Fayoum. A Practical Guide.* Second edition. Cairo.

Hunt, Lucy-Anne. 1985. "Christian-Muslim Relations in Painting in Egypt of the Twelfth to mid-Thirteenth Centuries: Sources of Wallpainting at Deir

es-Suriani and the Illustration of the New Testament MS Paris, Copte-Arabe 1/Cairo, Bibl. 94." *Cahiers Archéologiques* 33. pp. 111–155.

Hunt, Lucy-Anne. 1995a. "The fine Incense of Virginity: a late twelfth century wallpainting of the Annunciation at the Monastery of the Syrians." *Egypt, Byzantine, Ottoman and Modern Greek Studies.* 19. pp. 182–232.

Hunt, Lucy-Anne. 1995b. "The Newly Discovered Wallpainting of the Annunciation at Dayr al-Suryan." *Cahiers archéologiques* 43. pp. 147–152.

Immerzeel, Mat. February 1992. "Discovery of Wall-paintings in Deir Anba Bishoi (Wadi 'n Natrun)." Tito Orlandi (ed.) *Newsletter of the International Association for Coptic Studies* 30. pp. 8–11.

Innemée, Karel C. 1998. "The Iconographical Program of Paintings in the Church of al-'Adra in Deir al-Sourian: Some Preliminary Observations." SKCO 3. pp. 143–149.

Innemée, Karel C. 1999. "New Discoveries at Deir al-Sourian, Wadi al-Natrun." SKCO 6/1. pp. 213–219.

Innemée, Karel C. "The Wall-paintings of Deir Anba Bishoi (Red Monastery) near Sohag." *Proceedings of the Seventh International Congress of Coptic Studies, 27 August–2 September 2000,* Leiden University. In press.

Innemée, Karel C., Peter Grossmann, Konrad D. Jenner, Lucas van Rampay. 1998. "New Discoveries in the Al-'Adra Church of Dayr As-Suryan in the Wadi al-Natrun." *Mitteilungen zur christlichen Archäologie.* 4. pp. 79–103.

Jerome. 1841-64. *Regulae Sancti Pachomi: Praefatio* 7. J.P. Migne (ed.) *Patrologia Latina.* 23.64. Paris.

Judge, E.A. 1977. "The Earliest Use of Monachos for 'Monk' (P. Coll. Youtie 77) and the Origins of Monasticism." *Jahrbuch für Antike und Christentum* 20. pp. 72–89.

Krause, Martin. 1975. "Die Formulare der christlichen Grabsteine Nubiens." Kaziemierz Michalowski (ed.) *Nubia, recéntes rechèrches.* Warsaw. pp. 76–82.

Krause, Martin. 1991. "Libraries." CE. 5 pp. 1447–1450.

Krause, Martin. 1994. "Die Bedeutung alter Dokumentation für die koptische Kunst." S. Giversen, M. Krause, P. Nagel (eds.) *Coptology: Past, Present and Future. Studies in Honour of Rodolphe Kasser. Orientalia lovaniensia analecta* 61. Louvain. pp. 17–33.

Krause, Martin. 1998. *Das Mönchtum in Ägypten.* SKCO 4. pp. 149–174.

Krause, Martin and Klaus Wessel. 1966. "Bawit." *Reallexikon zur byzantinischen Kunst.* Vol. 1. Stuttgart. cols. 568–583.

Leipoldt, Johannes. 1903. *Schenute von Atribe.* Leipzig.

Leroy, Jules. 1971. "Complément à l'histoire des couvents du Ouadi Natroun d'Evelyn White." BIFAO 70. pp. 225–233.

Leroy, Jules. 1974. "Moïse de Nisibe, Symposium Syriacum 1972." *Orientalia Christiana Analecta* 197. pp. 457–470.

Leroy, Jules. 1976. "Dix années de recherches sur les peintures murales des monastères coptes de haute et basse-Égypte." *Comptes rendus de l'académie des inscriptions et belles-lettres.* Paris. pp. 570–587.

Leroy, Jules. 1976a. "Le programme décoratif de l'église de St.-Antoine du désert de la mer rouge." BIFAO 76. pp. 347–379.

Leroy, Jules. 1978. "Le programme décoratif de l'église de St.-Paul du désert de la mer rouge." BIFAO 78. pp. 323–337.

Leroy, Jules. 1982. "Les peintures des convents du Ouadi Natroun, La peinture murale chez les copts II." MIFAO 101. Cairo.

van Loon, Gertrud J.M. 1999. *The Gate of Heaven. Wall Paintings with Old Testament Scenes in the Altar Room and the Hurus of Coptic Churches.* Leiden.

Lyster, William. 1999. *Monastery of St. Paul.* Cairo.

Meinardus, Otto F.A. 1965. "Recent Developments in Egyptian Monasticism." *Oriens Christianus* 49. pp. 79–89.

Meinardus, Otto F. A. 1967/68. "Eighteenth-Century Wall-Paintings in the Church of St. Paul the Theban, Dayr Anba Bula." BSAC 19. pp. 181–197.

Meinardus, Otto F.A. 1969/70. "Some Lesser Known Wall-Paintings in the Red Monastery at Sohag." BSAC 20. pp. 111–117.

Meinardus, Otto F.A. 1976. "Semi-Domes of the Red Monastery at Sohag." BSAC 22. pp. 79–86.

Meinardus, Otto F.A. 1977. *Christian Egypt. Ancient and Modern*, revised edition. Cairo.

Meinardus, Otto F.A. 1981. "Die Nischen-Fresken im Roten Kloster bei Sohag." *Oriens Christianus* 65. pp. 148–162.

Meinardus, Otto F.A. 1992. *Monks and Monasteries of the Egyptian Desert*, revised edition. Cairo.

al-Meskeen, Matta. 1984. *Coptic Monasticism and the Monastery of St. Macarius. A Short History.* Cairo.

al-Meskeen, Matta. 1991. "Dayr Anba Maqar." CE 3. pp. 748–756.

Meyer, Robert T. Palladius. 1964. *The Lausiac History.* New York.

Mohamed, Mahmoud Ali and Peter Grossman. 1991. "On the Recently Excavated Monastic Buildings in Dayr Anba Shinuda: Archaeological Report." BSAC 30. pp. 53–63. *The Monastery of St. Bishoy*, Wadi al-Natrun.

Monneret de Villard. Ugo. 1925/26. *Les Couvents près de Sohag.* 2 vols. Milan.

Monneret de Villard. 1927. *Il monastero di S. Simeone presso Aswân.* 2 vols. Milan.

Monneret de Villard. 1927a. *Description générale du Monastère de Snt Siméon à Aswan.* Milan.

van Moorsel, Paul. 1986. "The Vision of Philotheus (on Apse-Decoration)." M. Krause (ed.) *Nubische Studien.* Mainz. pp. 337–340.

van Moorsel, Paul. 1991. "Dayr al-Baramus: Church Paintings." CE 3. p. 793 f.

van Moorsel, Paul. 1991a. "Dayr Anba Antuniyus: Wall Paintings." CE 3. pp. 726–728.

van Moorsel, Paul. 1991b. "Dayr Anba Bula: The Old Church." CE 3. pp. 742–744.

van Moorsel, Paul. 1992. "Treasures from Baramus: With Some Remarks on a Melchizedek Scene." ICCopts 4/1. pp. 171–177.

van Moorsel, Paul. 1994. "The Medieval Decoration of the Church of St. Paul the Hermit: as known by 1700 A.D." C. Berger et al. (eds.) *Hommages à Jean Leclant*. Varia 4. Bibliothèque d'Étude 106/4. pp. 395–401.

van Moorsel, Paul. 1995. "La grande annonciation de Deir es-Sourian." BIFAO 95. pp. 517–537.

van Moorsel, Paul. 1995b. "Les peintures du monastère de St.-Antoine près de la mer Rouge." MIFAO p. 112. Cairo.

van Moorsel, Paul. 1995c. "On Medieval Iconography in the Monastery of St. Paul near the Red Sea." C. Moss and K. Kiefer (eds.) *Byzantine East, Latin West. Art-Historical Studies in Honor of Kurt Weitzmann*. Princeton, N.J. pp. 283–285.

van Moorsel, Paul. 1998. "A Different Melchizedek? Some Iconographical Remarks." SKCO 3. pp. 329–340.

van Moorsel, Paul. In press. *Les peintures du Monastère de St.-Paul près de la Mer Rouge.*

van Moorsel, Paul and Mathilde Huijbers. 1981. "Repertory of the preserved Wall paintings from the Monastery of Apa Jeremiah at Saqqara." H. Torp et al. M*iscellanea Coptica. Acta ad archaelogium et artium historiam pertinentia* 9. Rome. pp. 125–186.

de Morgan, J., U. Bouriant, G. Legrain, G. Jéquier, & A. Barsanti. 1894. *Catalogue des monuments et inscriptions de l'Égypte antique.* ser. 1. vol. 1. Vienna.

Norris, Kathleen. 1996. *The Cloister Walk*. New York.

Partrick, Theodore Hall. 1996. *Traditional Egyptian Christianity. A History of the Coptic Orthodox Church*. Greensboro, NC.

Pearson, Birger A. 1986. "Earliest Christianity in Egypt: Some Observations." Pearson & Goehring. 1986. pp. 132–159.

Pearson, Birger A. and James A. Goehring (eds.) 1986. *The Roots of Christianity*. Philadelphia.

Quibell, James E. 1908. *Excavations at Saqqara. 1906–1907*. Cairo.

Quibell, James E. 1909. *Excavations at Saqqara. 1907–1908*. Cairo.

Quibell, James E. 1912. *Excavations at Saqqara. 1908–1909*, Cairo.

Rassart-Debergh, Marguerite. 1981. "La peinture copte avant le XIIe siècle. Une approche." H. Torp et al. *Miscellanea Coptica. Acta ad archaelogium et artium historiam pertinentia* 9. Rome. pp. 221–285.

Rassart-Debergh, Marguerite. 1981a. "La décoration pictoral du monastère de Saqqara. Essai de reconstruction." H. Torp et al. *Miscellanea Coptica. Acta ad archaelogium et artium historiam pertinentia* 9. Rome. pp. 9–124.

Rassart-Debergh, Marguerite. 1981b. "Quelques remarques iconographiques sur la peinture chrétienne à Saqqara." H. Torp et al. *Miscellanea Coptica. Acta ad archaelogium et artium historiam pertinentia* 9. Rome. pp. 207–220.

Rassart-Debergh, Marguerite. 1981c. "A propos de trois peintures de Saqqara." H. Torp et al., *Miscellanea Coptica. Acta ad archaelogium et artium historiam pertinentia* 9. Rome. Institutum Romanum Norwegiae. pp. 187–205.

Rassart-Debergh, Marguerite. 1991. "Coptic Monastery Paintings." CE 5. pp. 1659–1661.

Rassart-Debergh, Marguerite. 1991a. "Dayr Apa Jeremiah: Paintings." CE 3. pp. 777–779.

Rubenson, Samuel. 1995. *The Letters of St. Antony. Monasticism and the Making of a St..* Minneapolis.

Russell, Norman. 1980. *The Lives of the Desert Fathers. The Historia Monachorum in Aegypto.* Kalamazo.

Russell, Norman. 2000. *Cyril of Alexandria.* London.

Rutschowscaya, Marie-Hélène. 1995. "Le monastère de Baouit - état de publications." C. Fluck et al. (eds.) *Divitiae Aegypti. Koptologische und verwandte Studien zu Ehren Martin Krause.* Wiesbaden. pp. 279–288.

Samuel (Bishop). 1998. "New Discoveries in the Area of the Monastery of John the Little." *Acts du symposium des fouilles coptes, Le Caire 7–9 November 1996.* Société d'Archéologie Coptes. Caire. pp. 93–99.

Samuel (Bishop) and Grossmann, Peter. 1999. "Researches in the Laura of John Kolobos (Wadi Natrun)." SKCO 6/1. pp. 360–362.

Sauneron, Serge. 1974. "Les travaux de l'Institut français d'Archéologie orientale en 1973–1974." BIFAO. 74. pp. 183–233.

Severin, Hans-Georg. 1977. "Zur Süd-Kirche von Bawit." MDAIK 33. pp. 113–124.

Severin, Hans-Georg. 1991. "Bawit: Archaeology, Architecture and Sculpture." CE 2. pp. 363–367.

Severin, Hans-Georg. 1991a. "Dayr Apa Jeremiah: Sculpture." CE 3. p. 776 f.

Severin, Hans-Georg. 1991b. "Dayr Anba Shinudah: Architectural Sculpture." CE 3. p. 769 f.

Severin, Hans-Georg. 1991c. "Dayr Anba Bishoi: Architectural Sculpture." CE 3. p. 739 f.

Severin, Hans-Georg. 1998. "Zur Skulptur und Malerei der spätantiken und frühmittelalterlichen Zeit in Ägypten." SKCO 4. pp. 295–338.

Socrates. 1978. "Ecclesiastical History." Zeno A.C. (trans.) *Nicene and Post-Nicene Christian Fathers.* 2/2. Grand Rapids. Michigan.

Timbie, Janet. 1998. "A Liturgical Procession in the Desert of Apa Shenute." David Frankfurter (ed.) *Pilgrimage and Holy Space in Late Antique Egypt,* Leiden-Boston-Köln. pp. 415–441.

Trigg, Joseph W. 1998. *Origen.* London.

Urbaniak-Walczak, Katarzyna. 1992. "Die conceptio per aurem." *Arbeiten zum spätantiken und koptischen Ägypten.* 2. Altenberge.

Urbaniak-Walczak, Katarzyna. 1993. "Drei Inschriften aus der Kirche des Erzengels Gabriel in Deir An-Naqlun im Faijum." BSAC 32. pp. 161–169.

Vansleb, J.M. 1678. *The Present State of Egypt.* London.

Veilleux, Armand. 1980–1982. *Pachomian Koinonia.* 3 vols. Kalamazoo.

Veilleux, Armand. 1986. "Monasticism and Gnosis." Pearson and Goehring. 1986. pp. 271–306.

Vivian, Tim. 1998. "The Monasteries of the Wadi Natrun, Egypt. A Personal and Monastic Journey." *American Benedictine Review.* 49/1. pp. 3–32.

Vivian, Tim. 1999. "A Journey to the Interior. The Monastery of St. Antony by the Red Sea." *American Benedictine Review.* 50/3. pp. 277–310.

Vivian, Tim and Athanassakis, Apostolos N. 2002. *The Life of Antony.* Kalamazoo.

de Vogüé, Adalbert. 1991. *Histoire littéraire du mouvement monastique dans l'antiquité, première partie, Le monachisme latin.* Paris.

Ward, Benedicta. 1984. *The Sayings of the Desert Fathers,* revised edition. Kalamazoo.

Walters, C.C. 1974. *Monastic Archaeology in Egypt.* Warminster.

Watson, John. 1996. "Abba Kyrillos. Patriarch and Solitary." *Coptic Church Review* 17/1 & 2. pp. 7–48.

Wietheger, Cäcilia. 1992. *Das Jeremias-Kloster zu Saqqara unter besonderer Berücksichtigung der Inschriften. Arbeiten zum spätantiken und koptischen Ägypten.* 1. Altenberge.

Wipszycka, Ewa. 1996. *Études sur le christianism dans l'Égypte de l'Antiquité tardive. Studia Ephemeridis augustinianum.* 52. Rome.

Zanetti, Ugo. 1986. *Les manuscrits de Dayr Abû Maqâr: Inventaire. Cahiers d'Orientalisme.* 11. Genève.

Zibawi, Mahmoud. 1995. *Die christliche Kunst des Orients.* Milan.

Glossary

Ambon: A pulpit.

Anchorite: An ascetic hermit.

Arcature: A small-scale arcade; a system of arches.

Architrave: The main beam which rests on the top of columns; also the various parts framing a window or a doorway.

Archivolt: The ornamental moulding around the arch, often on the underside.

Atrium: An open court in front of a church, surrounded on four or at least three sides by porticoes.

Cenobitic (monasticism): A form of monasticism in which monks live together as a community.

Chapter house: A building attached to a cathedral or a monastery, used as a meeting place for the monks or any general assembly.

Chrism: Holy mayron, sacred oil used in anointing and ceremonies of consecration.

Clipeus: A round shield used as a frame for portraits.

Codex: A manuscript volume of an ancient text.

Colophon: A statement at the end of a manuscript concerning the copyist and other persons.

Dayr: A monastery with an enclosure wall.

Deisis: The scene of the enthroned Christ flanked by the Holy Virgin Mary and St. John the Baptist.

Dyophysitism: Movement which began around Antioch. Adherents emphasized the two separate human and divine natures of Christ after the Incarnation. See *Monophysitism*.

Feretory: A shrine dedicated to the body of a saint.

Flabellum: A large ceremonial fan.

Keep or *Qasr*: A multistory tower with defensive capabilities to protect monks during long sieges.

Khurus: A narrow transitive hall reserved for the clergy, preceding the sanctuary.

Koinonia: monastic community.

Laura: A group of cells inhabited by monks without an enclosure wall.

Mandorla: Oval enclosing a scene.

Martyrium: A building marking the place of martyrdom as well as housing the dead saint.

Melkite: A Christian sect which supported the decrees of Chalcedon (451 CE).

Mephorion: Woman's mantle which covers the head.

Monophysitism: Movement which originated in Alexandria. Adherents emphasized the union of Christ's human and divine natures after the Incarnation. Came to refer generically (and often pejoratively) to those who, like the Copts, did not accept the decrees of Chalcedon (451 CE). See *Dyophysitism*.

Narthex: An entry vestibule or an entrance hall, usually located at the west end in Egyptian church architecture, but rarely found in monastic churches.

Nimbus: A ring or emanation of light around the head of an angel or a saint.

Orans: A frontal figure with arms raised in prayer.

Oratory: A small chapel adjoining the cells of the monks for private worship.

Ostracon: A chip of limestone or a piece of broken pottery carrying inscriptions.

Pallium: A large cloak derived from a Roman outer garment.

Parekklesia: A small chapel or a subsidiary church adjoining a main church.

Scriptorium: A room, especially in a monastery, set apart for the transcription of manuscripts.

Shaykh: A venerable old man; Muslim leader or head of a Muslim group.

Squinch: A small straight or arched structure across an interior corner of a tower, used to support a square structure such as an octagon or a spire.

Synaxarium: A liturgical book containing texts about saints and feasts, arranged according to the calendar.

Tempera: The technique of painting with tempera, a painting medium for powdered pigments containing egg yolk and water.

Triconch: A square, circular, or oblong room expanded on three sides by semicircular rooms.

Tunica: A knee-length garment, originally a Roman undercloth.

Visitation: The visit of the Holy Virgin Mary, who was pregnant with Christ, to St. Elizabeth, who was pregnant with John the Baptist.

Vizier: A high official in medieval Muslim government; chief minister.

Index

St. Apollo, 62, 117 *see also* Apa
Apollo the Great
St. Arsenius, 80
St. Athanasius (Patriarch), 1, 7, 13,
14, 22, 24, 26, 55, 70, 72, 85
St. Athom, 78
St. Augustine, 1, 22
St. Barsum the Syrian, 42, 80
St. Basil the Great, 19, 22
St. Basilidis, 62
St. Benedict, 22
St. Benjamin, 58
St. Bishoi, 29, 32, 33, 36, 50 *see also*
Pshoi
St. Chrysostomus, John, 1
St. Claudius, 59, 77–78
St. Cyril (Patriarch), 13, 14, 19, 86, 94
St. Demetrius, 122
St. Dioscorus (Patriarch), 50, 85
St. Domitius, 38, 41, 80
St. Eusebius, 62
St. George, 62, 78, 81, 81
St. Gregory, 12
St. Ignatius, 50
St. Isaac the Priest, 80
St. Iskhyrun, 46, 62
St. Jeremiah, 120
St. Jerome, 1, 2, 22, 24, 72, 88, 115
St. John, 41
St. John (hermit) 63
St. John the Apostle and Evangelist,
51, 62, 70, 93, 100
St. John the Baptist, 20, 42, 58, 59,
79, 92
St. John Kame, 33, 50, 55
St. John the Little, 28, 43, 62, 73, 80
St. Joseph, 51, 58
St. Justus, 62
St. Macarius of Alexandria, 63
St. Macarius, 80
St. Macarius (Bishop of Tikoou), 63

St. Mark the Evangelist, 6, 11, 19, 50,
55, 58, 59, 70, 85
St. Macarius the Great, 7, 13, 24, 26,
28, 35, 36, 38, 41, 62, 63, 122
St. Mary, the Holy Virgin, 13, 50, 51,
52, 53, 61, 79, 82, 99, 100, 107,
112; *enthroned with Child: 40,
41, 55, 69, 70, 80, 85, 86, 91, 92,
93, 118, 119; nursing Virgin
(Galaktotrophousa; lactans), 49, 52*
St. Maximus, 38, 41, 80
St. Mena, 59, 77
St. Mercurius, 70, 81, 89
St. Michael, 42, 62
St. Misael, 62
St. Moses the Black, 28, 41, 42, 80
St. Onnophrius, 42, 62, 63, 122
St. Pachom, 1, 2, 7 *see also* St.
Pachomius
St. Pachomius, 13, 24, 26, 27, 29, 42,
62, 80, 94 *see also* St. Pachom
St. Pamun, 123
St. Paphnutius, 38, 42
St. Paul (Apostle), 11, 50, 75
St. Paul the Hermit, 41, 61, 62, 72,
73, 80, 88, 92
St. Paul of Psilikous, 119
St. Paul of Tamweh, 46
St. Paul the Simple, 80
St. Paul, Cave of, 89
St. Peter (Apostle), 11, 50, 51, 70, 75,
119
St. Phoibdmon, 78
St. Pigimi, 62
St. Pigoshe, 70
St. Piro, 78
St. Pisentius (Bishop), 80
St. Pshoi, 43, 44, 50, 80, 101
St. Samuel of Qalamun, 62, 65, 80
St. Severus (Severus of Antioch)
(Patriarch), 47 50, 85